MARY WHYTE

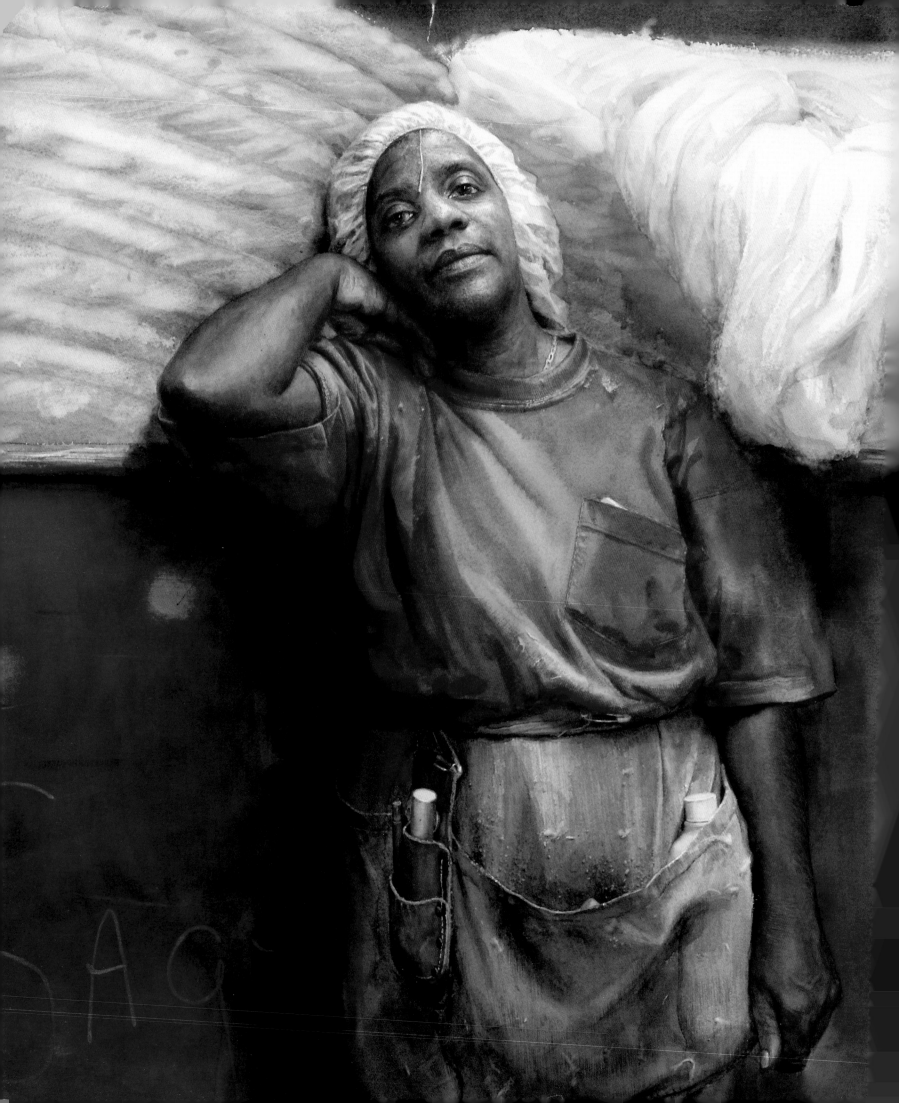

WORKING SOUTH

Paintings and Sketches by Mary Whyte

Foreword by Martha Severens

THE UNIVERSITY OF SOUTH CAROLINA PRESS

© 2011 Mary Whyte

Published by the University of South Carolina Press
Columbia, South Carolina 29208

www.sc.edu/uscpress

Manufactured in China

20 19 18 17 16 15 14 13 12

10 9 8 7 6 5 4 3

Library of Congress Cataloging-in-Publication Data
Whyte, Mary.
 Working South : paintings and sketches / by
Mary Whyte ; foreword by Martha Severens.
 p. cm.
 Includes index.
 ISBN 978-1-57003-966-9 (cloth : alk. paper) —
ISBN 978-1-57003-967-6 (pbk : alk. paper)
 1. Whyte, Mary—Themes, motives. 2. Working
class in art. 3. Southern States—In art. I. Title.
 ND1839.W49A4 2011
 759.13—dc22

 2010025224

FRONTISPIECE: *Spinner,* detail. Textile mill worker, Gaffney, S.C.

For Smitty

"Every man's work, whether it be literature, or
music or pictures or architecture or anything else,
is always a portrait of himself."

SAMUEL BUTLER (1835–1902), *The Way of All Flesh*

CONTENT

FOREWORD

Working South is not only the title of a recent body of work by Mary Whyte, but also a metaphor for her personal transition from the North to the South. Through her art and sincere personality, she has worked her way into the hearts and minds of southerners, whether natives or recent arrivals. Like the many sitters in her paintings, Whyte is emblematic of a New South, except for the fact that her subjects represent industries that are shrinking, if not disappearing, while her reputation and horizons are ever expanding.

This series is not her first focusing on southerners; for ten years she painted members of a church community not far from her adopted home on Seabrook Island near Charleston, South Carolina. Culminating in a book and a traveling exhibition, *Alfreda's World* celebrates the warmth and generosity of spirit that embraced Whyte shortly after her arrival in the area. Moving from Philadelphia, where she had attended the Tyler School of Art, she was primed for a nurturing environment after a recent bout with cancer. As she explains: "We knew that we had to move to a place that would give us deeper meaning to our lives—a place where we could reinvent ourselves and start over."[1] Her encounter with Alfreda and her fellow quilt makers at the Hebron Zion St. Francis Senior Center on Johns Island was a happy accident that bore fruit in many ways.

Working South is a different endeavor, created within a tighter time frame and with a clearer, less personal objective from the start. Originating from a discussion with a prestigious Greenville banker while he sat for his portrait, the concept evolved; during one of his sittings, they both were struck by headlines in the *Greenville News* announcing that yet another textile mill was closing, displacing many long-time workers. The seeds of *Working South* were sown.

Whyte, who grew up in Chagrin Falls, Ohio, not far from Cleveland, was familiar with individuals who lived simply and were hardworking. A precocious artist who as an eighth-grader sold her first painting for twenty dollars, she made frequent trips to Amish country, where she sketched members of the community performing menial tasks. She was propelled by a desire to record what she saw: "I wanted to capture as much as I could of it on paper, save it and protect it before it was changed and lost forever. I feared it was a community shrinking acre by acre and generation by generation as the modern world

buffed up against it and frayed its corners."[2] A similar motivation prompted both *Alfreda's World* and *Working South.*

As a relative newcomer to coastal South Carolina, Whyte found inspiration in the area's longstanding preservation ethos. The City of Charleston is proud to have passed this country's first historic preservation ordinance, which has served to protect its built environment and has transformed dilapidated streetscapes into a highly touted tourist destination. In recent years this same instinct has extended to land conservation, especially along the Ashley River, and to the Gullah culture, which manifests itself in language, music, and quilt and basket making.

Through their art and writing, two Charleston women artists stimulated the preservation movement, and both can be seen as role models for Whyte. Alice Ravenel Huger Smith used evocative line drawings for her 1917 book, *The Dwelling Houses of Charleston, South Carolina,* which inspired local homeowners to restore their properties. The book also brought national attention to Charleston's architectural legacy. Smith was a watercolorist at heart and, like Whyte, used the medium to convey the romantic beauty of her native lowcountry. One of Smith's best-known endeavors was the series of thirty watercolors that became *A Carolina Rice Plantation of the Fifties,* an undertaking not unlike *Working South.* Smith's work is a visual documentation of the rice industry, which had fallen on hard times during her lifetime. In her *Reminiscences,* Smith described her process and her reasoning:

> Those pictures have been the result of many trips in the country, and many interesting visits to plantations still being planted at that time. I threw the book *back* to the Golden Age before the Confederate War so as to give the right atmosphere because in my day times were hard. . . . As the old ways of planting were passing out—indeed, the plantations themselves were gradually disappearing—I knew that a series showing that period would never again be painted when my generation should have disappeared also, so I gave the thirty pictures to the Carolina Art Association, after the book appeared.[3]

Smith's protégé, Elizabeth O'Neill Verner, was an active preservationist whose etchings—which made perfect souvenirs—fueled the area's nascent tourist business. But unlike her mentor who preferred the countryside, Verner was an accomplished figure painter who used pastel to depict Gullah flower vendors. When their entire industry was threatened by a new ordinance, Verner marched to city hall to advocate for the vendors, arguing "that Charleston had more free advertisement in nationally known magazines than any other city in the country and that in every picture a flower woman was strategically placed to give local color."[4]

Like Alice Smith, Whyte is a proficient watercolorist, and both follow in the footsteps of Winslow Homer and John Singer Sargent, two giants of American art who helped to legitimize the medium at the turn of the last century. Scholars have dubbed watercolor a quintessentially American medium. Its evolution parallels the history of art in this country, from literal realism to personal expression. First used by artist-explorers who came to these shores with the idea of recording flora, fauna, and native life, watercolor continues

to be the medium of choice for "Sunday painters" and such highly regarded contemporary artists as Andrew Wyeth and Stephen Scott Young.

Known primarily as a figure painter, Whyte also paints plein air landscapes in oil, but admits, "I really do love watercolor the best because of that ethereal quality you can so readily get with the medium. Watercolor also lends itself to painting skin because of its translucent nature."[5] She has mastered both the flesh tones of African Americans as well as the crinkly transparent skin of her older subjects. *Lovers* (p. 25), her depiction of a Caucasian quilter from Berea, Kentucky, is a superb example of her talent for handling the color, texture, and sagging weight of an old woman's skin, while *Spinner* (p. 13) displays Whyte's ability to capture the soft, slightly moist flesh of a middle-aged mill worker.

At Tyler only one watercolor course was offered; on the first day of class, Whyte's instructor noticed she already had some facility with the medium and thus offered her little instruction or criticism for the remainder of the semester. More or less on her own, Whyte has persevered, honing her skills as a watercolorist and working hard at drawing. As she opines: "Watercolor is not forgiving. If you make a mistake, you can't paint over it without making a pile of mud. You can't really hide what's underneath it. You need sound drawing skills; you only get one shot at it."[6] She has become so adept at watercolor that she has even authored two books: a handbook, *Watercolor for the Serious Beginner,* and *An Artist's Way of Seeing,* a first-person reverie that reveals her love affair with the medium and with color.

Perhaps in response to her less-than-satisfactory experience in art school, Whyte has become a highly sought-after teacher, taking on private students and offering workshops. Since 2003 she has conducted workshops at the Greenville County Museum of Art, where she welcomes aspiring artists at all levels, even maintaining that the less competent keep her focused and have more to gain. They are in awe of her ability to capture a likeness, and in return she acknowledges that they have taught her some of the "most valuable lessons about painting and life."[7] As part of the workshop, she takes her students on a visit to the museum's collection of watercolors by Andrew Wyeth, which she analyzes and dissects with great sensitivity. She not only admires this master of American art, but also thoroughly understands his technique as well as his passion. Like him, she "believes our best expressions will come from what we know best."[8]

Preparation and study are key ingredients for a successful painting. Whyte religiously employs preparatory sketches—small, quick notations that help her gather information about her sitters as well as possible settings. In *Watercolor for the Serious Beginner* Whyte advocates the use of 3- x 4-inch thumbnails, which she defines as "simply a road map, planning the distribution of lights and darks and the important elements of design."[9] These she maintains as resource material, much like a scholar uses his or her library. Meticulously organized, she returns to them often for inspiration and for the small nuances that are so meaningful in the finished paintings.

The thumbnails are also a vehicle for determining her composition. One of the first decisions is what format: horizontal or vertical? In the series *Working South* one-third are vertical, the typical orientation for a portrait. But because Whyte is also telling a story about the occupations of her subjects, she often uses a broader format as exemplified by

Boneyard (p. 59) and *Crossing* (p. 69), in which the men are set to one side and juxtaposed against landscape details. Whyte's preparatory sketches help her decide where she is going to place the figure, always an important consideration but imperative for a series, as she would not want all the figures in the center or facing the same direction. Further variety comes when Whyte relegates some of her sitters, such as the lumberyard worker in *Edger* (p. 55) or the elevator operator in *Fourth Floor* (p. 81), to lower quadrants, allowing their environments to enfold them.

Whyte employs photographs she has taken as another aid in the development of her paintings, a process long frowned on by traditionalists. But many revered nineteenth-century painters, including Edgar Degas and Thomas Eakins, were proficient photographers and employed photographs as helpful tools for crafting their paintings. Whyte fully understands how photographs can become a crutch, and she largely uses them to jog her memory or to assist with a particular detail. Typically she emphasizes the faces and the hands of her subjects, which she renders with utmost realism while allowing clothing and the background to fade away into less precision.

Because painting in watercolor is so demanding and requires hours of practice, patience, and perseverance, Mary Whyte can empathize with the laborers she has selected for *Working South*. Like the artist herself, they have had to develop the skills and intuition to perform their tasks at the highest level. For the individuals who depend on nature—the farmers, the fishermen—they must grapple with weather: wind, rain, tide, and the lack thereof. Others may be more dependent on machines, but even then knowledge of mechanical idiosyncrasies is beneficial. The series reveals the artist's respect and understanding of the workers she paints.

The genesis of the series occurred in the upstate, once acclaimed the capital of the textile industry, and many of the paintings deal with aspects of textile production from the cotton picker to the spinner. Ironically the southern mills grew at the expense of their northern counterparts, only to suffer the same fate at the end of the twentieth century, when companies moved to Mexico or China in pursuit of cheaper labor. To reinforce her connection with the passing of the industry, Whyte has leased a textile mill worker's house near Simpsonville, South Carolina, as a retreat and a studio. She admits to living like a monk while there, without the distractions of modern life such as television. This allows her to concentrate thoroughly on the task at hand, working twelve-hour days not unlike the shift workers of the past.

The series, however, has evolved beyond just the textile industry to embrace other occupations threatened for one reason or another. Some, such as the elevator operator, are victims of technology, while others, such as the shoeshine man or the drive-in theater owner, have lost customers because of changes in fashion. Nowadays people tend to frequent fast food outlets because of aggressive marketing and familiar menus, passing by the family diner. So-called convenience also plays a role; if it's not available at Wal-Mart or on the Internet, it may be too much trouble to seek out a handmade, one-of-a-kind treasure such as a quilt.

In the accompanying narrative, Whyte explains her methodology as well as some of her adventures. "One has led into another," she says. "I found something profound about their faces and features. I didn't think it was necessary to get to know them personally. It's

more of an artist's journey, in some ways haphazard, throughout the South with people I have had the good fortune to meet." Whyte sees herself as a storyteller: "Every place, every person has a story to tell. As artists our mission is to tell that story—not as journalists, but more as poets."[10] But she does not simply illustrate their stories; like Andrew Wyeth, she is dismissive when labeled an illustrator, even though she has illustrated more than a dozen children's books.

One tactic that helps Whyte objectify her subjects is her reluctance to bring them into her studio. Instead she prefers to see them in their own settings, complete with the landscapes and tools they use in their work. In this respect she is not unlike the photographer Arnold Newman, who ingeniously posed artistic personalities in the context of their work. Thus Georgia O'Keeffe's patrician profile is seen against a cow skull and desert terrain, and Igor Stravinsky is framed by an open grand piano.

For each figure in *Working South,* Whyte has created a distinctive and meaningful context. The shoeshine man is thoroughly alone against a somber background, while the beekeeper's daughter is radiant and busy in a bower of flowers and light. The aroma surrounding the woman frying herring is palpable, while the gloom pervading the young men in *Fifteen-Minute Break* reiterates the treacherousness of their work and the imposing scale of the boat in *Hull* reinforces the muscularity of the boat builder.

Whyte's paintings are not portraits; in fact she considers herself a genre painter, one who renders everyday people in everyday circumstances. Jan Vermeer is a shining example of traditional genre painting, but he painted figures at leisure more than at work. The French Barbizon painter Jean-François Millet was widely revered as a champion of the peasant who labored the fields, and not unlike the way Whyte sees her subjects, he valued their simple lifestyle and work ethic as industrialization began to change the Western world. As twentieth-century painters gravitated toward abstraction, it was only the painters of the American scene and the New Deal who dealt with laborers, usually in a laudatory manner. Despite Thomas Hart Benton's penchant for the anecdotal, Whyte's work most resembles his, given his desire to capture each region's customs and predilections. He depicted lone farmers battling the forces of nature, steelworkers in fiery furnaces, and lumbermen felling trees. Like Whyte he traveled extensively in pursuit of imagery, as he recalled: "I traveled without interests beyond those of getting material for my pictures. I didn't give a damn what people thought, how they ate their eggs or approached their females, how they voted, or what devious business they were involved in. I took them as they came and got along with them as best I could."[11]

In looking over *Working South,* one feels that Mary Whyte has no such detachment. She lovingly paints her figures and their surroundings, often taking one's breath away with her exquisite and sensitive detail and her ability to render smoke. As she explains: "Subject matter is neither pretty nor ugly, as the beauty of a painting lies in the work itself. Everything is worthy of being painted, even a gray day. . . . Good painting is the result of close observation and your thoughtful response."[12] In *Working South* she has given the viewer a lot to consider.

Martha Severens
Curator, Greenville County Museum of Art
South Carolina

NOTES

1. Mary Whyte, *Alfreda's World* (Charleston: Wyrick & Company, 2003), 1.

2. Ibid., 3.

3. Alice Ravenel Huger Smith, "Reminiscences," in Martha R. Severens, *Alice Ravenel Huger Smith: An Artist, A Place and A Time* (Charleston: Carolina Art Association / Gibbes Art Museum, 1993), 97.

4. Elizabeth O'Neill Verner, unpublished autobiography, Verner papers, South Carolina Historical Society, quoted in "Doing and Creating: A Biographical Sketch," in Lynn Robertson Myers, ed., *Mirror of Time: Elizabeth O'Neill Verner's Charleston* (Columbia: McKissick Museums, University of South Carolina, 1983), 13–14.

5. Lauren Harris, "Mary Whyte: Capturing the Unseen," *International Artist* (October/November 2008): 45

6. David Aldestein, "Working with Water," *Apalachicola Times,* January 15, 2009.

7. Mary Whyte, *An Artist's Way of Seeing* (Charleston: Wyrick & Company, 2005), 87.

8. Meredith E. Lewis, "Technique Is Vocabulary; Expression Is the Story," *American Artist* (December 2008): 35.

9. Mary Whyte, *Watercolor for the Serious Beginner* (New York: Watson-Guptill Publications, 1997), 25.

10. Mary Whyte, "Heart and Soul," *Artist's Magazine* (May 2003).

11. Thomas Hart Benton, *An Artist in America* (Columbia: University of Missouri Press, 1983), 77.

12. Whyte, *An Artist's Way,* 39.

ACKNOWLEDGMENTS

Every day I thank God for blessing me with the ability to paint. Painting is a solitary business and, for many artists, including myself, there are always numerous people behind the scenes, doing everything except hold the brush. My husband, Smith Coleman, has been and continues to be alongside me every step of the way and is my greatest source of encouragement. Janice Rossmann and Croft Lane have also been instrumental in nurturing this project along, as well as Marilynn McMillan, who has assisted my husband in creating some of the most beautifully crafted frames I have ever seen.

I am truly grateful to Jane O'Boyle, a gifted writer and genuine friend, as well as Linda Fogle and many others at the University of South Carolina Press for creating this book. Tom Styron, director of the Greenville County Museum of Art, was behind the project before the third painting was finished. And thanks go to Martha Severens, the former curator, for writing the foreword and for inspiring me as well as many others with her impressive grasp of art and history. I am grateful also to other museum administrators who have exhibited and encouraged my work, including Angela Mack at the Gibbes Museum of Art in Charleston, South Carolina. I owe thanks as well to Martha Teichner and Andy Merlis of CBS for their insight into this creative journey.

I have come to regard the Internet as one of humanity's greatest inventions when it comes to doing research, but I am convinced it will never surpass real books and real people. I am grateful to the many people who helped me and pointed me in the right direction: the Hogg family, the Worthingtons, Darrell and Connie McKinley, Dr. David Allgood, Tina Bucuvalis, Mary Margaret Miller, Nicholas Toth, Tracy Floyd, Janson Cox, Kipp Buis, Tom and Melissa Howell, Connie Hubbard, Pam and Mike Bigelow, Mack Whittle, and Bill Burnham.

And to the many people, in these paintings and not, who welcomed me into their lives and workplaces, allowing me the privilege and pleasure of painting them: I say thank you.

Lastly I am grateful to the art collectors who have truly blessed my life and have kept the lights on, the deepest of these thanks to John and Mary Lou Barter, who believed in me from the start.

And my beloved Smitty I thank first, and last, and always.

OVERLEAF:

By a Thread. Textile mill worker, Easley, S.C.

xv

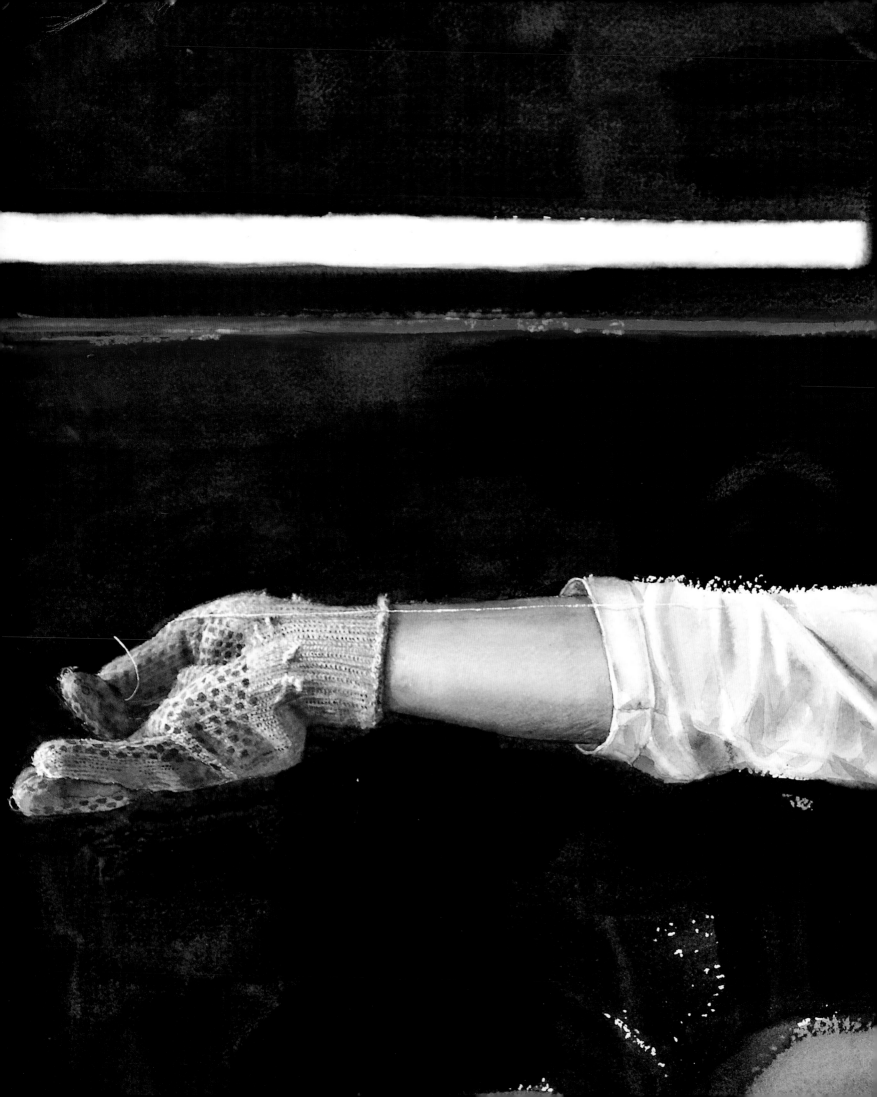

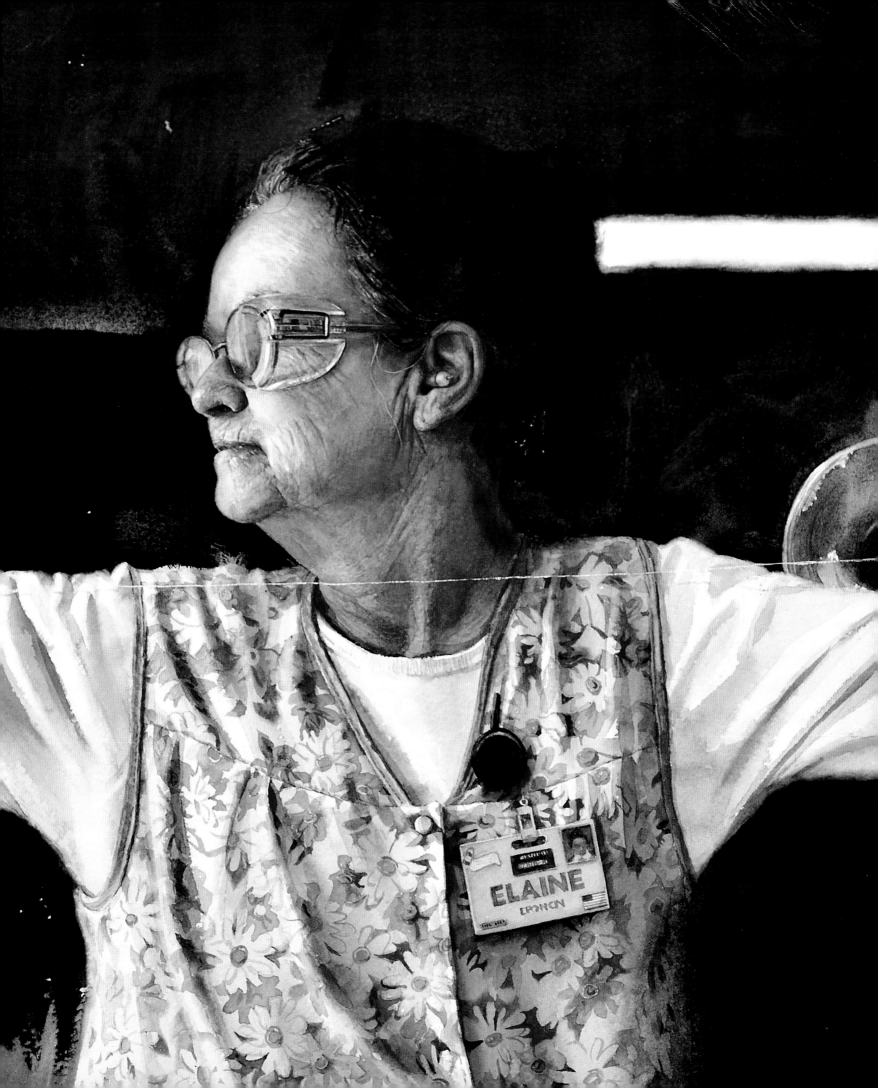

INTRODUCTION

It started with a newspaper article. I had driven to Greenville, South Carolina to paint a portrait of a bank president and was staying in one of the large hotels in town. The portrait would require a couple of painting sessions, but the bulk of the work would be done back home in my Seabrook Island studio.

At breakfast I sat in the hotel dining room and ordered the usual scrambled eggs and tea, reading the local newspaper. "Local Textile Mill to Close." Hundreds of long-time employees were being laid off. A photograph showed a woman in a loose smock and wearing a sort of shower cap. She was standing in front of a large loom, with hundreds of white threads crisscrossing behind her. The threads always started as white, and later were woven and dyed. The woman's face was slightly turned away from the camera, glancing down to her left. She looked like a grandmother who might live down the street, the one you always mean to ask her name. Or the one who stands behind you in the check-out lane at the grocery store or who sells you a cup of coffee. The caption under the picture didn't identify her other than as "an employee," as if it was a photograph of nobody. She was one of hundreds of people who live their lives under the radar. And she was about to lose her job.

Two hours later I was on the top floor of the bank building, sketching a middle-aged man in a dark suit who was perched on the edge of a mammoth desk. The light spilled in windows on two sides, giving an expansive view of the city. On the other side of the mahogany door, bank workers padded down long hallways lined with dark paneling and an exquisite art collection. I commented about the morning's news and how it might be interesting to paint a mill worker.

"In ten years all the textile mills might be gone," he said, not moving from his pose.

I had never been in a textile mill before, much less thought about the number of hands cotton passes through to be made into a T-shirt.

What was it like to spend an entire lifetime working in a mill? What was it like working in the only vocation you know, realizing that someday soon it may end?

A large segment of our population works unnoticed, year after year, in all kinds of jobs that are becoming outmoded, downsized, or phased out. These are the people who have spent the majority of their adult lives in jobs that their grandchildren may never see but

only read about in the history books. I wondered how much of our personal worth is tied to the importance of the job we do. And if the only work we have ever known ceases to exist, do we even matter?

A month later I was carrying my sketchbook into one of the mills.

The textile business in South Carolina had been one of the economic foundations of the state and the South. Ever since cotton became a major commodity, before the Civil War, the Palmetto State has produced generations of families whose lives are in some way tied to the cotton fields. If you weren't picking the cotton or working in the mill, you were in one of the businesses that serviced mills.

Male students from southern universities often said that on graduation they had two choices: work in the mill or work in agriculture. In 1960 the state census reported more than 160,000 people were employed in the textile mills and apparel manufacturing. By 2008 the Bureau of Labor Statistics reported the number to have dropped to less than 28,000.

The state is dotted with small towns built around hundreds of mills, often next to a river and railroad tracks. Mills became the center of social life, with their own baseball and basketball teams and with company-provided housing within walking distance to work. Employees paid rent based on the number of rooms they inhabited, with supervisors given slightly larger accommodations.

The houses that mill workers lived in are still easy to spot, as they are often uniform and modest, fanning out from the mill. Many of the mills are closed now, empty and abandoned, although some have been refurbished into condominiums and commercial spaces. They don't make textiles anymore, but many people, including artists, love high ceilings, beautiful wood floors, and large windows. I once had a studio in an old cigar factory in North Wales, Pennsylvania. I loved the light through those tall windows. I loved it so much that in winter I positioned my easel next to a kerosene heater and wore a knit hat and gloves.

The first working mill I visited was Alice Mills of Easley, South Carolina. I later learned that some mills and factories aren't very welcoming to a stranger toting a camera. A few company executives bristled at my request to paint a "vanishing industry." Well, who could blame them? I was shown the door more than once.

Mills are a cacophony of machinery and moving parts. Workers and visitors must wear earplugs by state law, a caution endorsed by older workers who admit to hearing loss from the earlier years. Because of the noise, I learned that the best place to talk to employees was in the canteen, or lunchroom, where I chatted with many workers on their coffee or lunch breaks. The sparse lunchrooms with vending machines are often outfitted with television screens

2

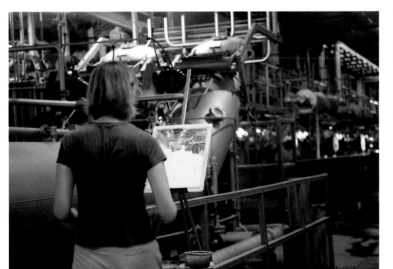

Several textile mills were happy to accommodate an artist and easel. I found it was a challenge to paint in unusual lighting with noisy machines, steam, and constantly moving workers.

where workers can monitor their machines and progress even while they are away from their post. Here I could freely talk with workers about their jobs.

"How do you like your job?" I asked shy, middle-aged Maureen. She had started working at the mill the day after she graduated from high school. She smiled, touching her delicate wedding band.

"I have no complaints," she said. "In fact, I'm grateful. The mill gave me a living, and a husband, too." Her husband, now retired from the mill, had been an employee there for thirty years.

Other workers were considerably less satisfied with their situation.

"We used to eat lunch outside under the trees," said one woman. Almost all the workers were women. "But we ain't allowed to do that no more. That was in the old days."

Others were new at the plant, having just started after a neighboring mill closed down three weeks earlier. Some of them had been given only one day's notice. One woman told me it was her second mill closing, her husband's third.

"Ever think about working somewhere else?" I asked.

"Work where?" asked an older woman. "The mill is all I ever known."

I started to make a list of the professions that were vanishing. People losing or having lost their employment included mill workers, tobacco farmers, elevator operators, shrimpers, and oystermen. My friends and family added to the list while reminiscing about the past. We remembered trips to the department store that had the big brass elevator and—more memorably—the white-gloved elevator operator. And who could forget the old diner waitress who served that tangy, homemade lemon meringue pie? Newspapers are no longer delivered by cycling teens but slung out a car window by a sleepy adult (or viewed on a computer screen). Most lemon meringue pies come shrink-wrapped and frozen like hockey pucks, purchased in a big-box national chain store.

Many of the occupations on my list were recent casualties of outsourcing. Manufacturing is moving to Mexico, India, China and other developing nations. Other countries are cheaply producing our sponges, boats, paper, shrimp, shoes, and hats. We care more for price than for quality.

A polluted environment is also taking its toll on American jobs. Development has flooded our streams and bays with toxins. The Chesapeake Bay and the Gulf Coast have increasing numbers of "dead zones," areas where water life is nonexistent, caused by major oil spills or the runoff of pollutants from factories and cities. Jobs for oystermen, oyster shuckers, crab pickers, and shrimpers used to be plentiful, but 85 percent of the world's oyster beds are now gone. Now many of our bivalves and crustaceans are imported frozen from countries on the other side of the world.

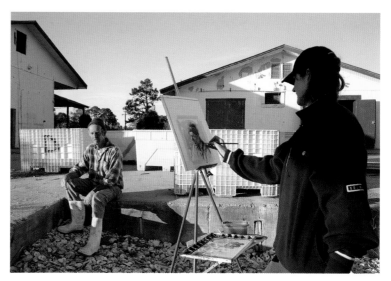

I spent a couple of weeks painting in Apalachicola, Florida, where I met and photographed several oystermen. Photograph by David Adlerstein

Many of our river industries are experiencing a similar fate. Along the coffee-and-cream-colored Roanoke River in eastern North Carolina, there were once dozens of fish shacks where locals pulled in riverwide nets of herring each spring. I visited what may well be the last fish shack along the river, where fishing for herring had just been banned because the stock had been depleted.

I was unable to paint some professions on my list, simply because I was too late. One such example: tobacco auctioneer. I met many southerners who remembered the excitement of the fast-paced auctions amid mounds of pungent tobacco piled in drafty warehouses. But by the time I started making phone calls, the last of the tobacco warehouses I knew of had closed. Another professional, the milliner, almost didn't happen. My hometown of Charleston had had a milliner, whom I had met a few years before. Her shop had been a fixture in the African American community for years. Because I knew the woman and since the store was not far from my home, I decided to put off her portrait until later. By the time I was ready to paint the milliner, my phone calls went unanswered, and the shop was empty.

I still regret that I missed my Charleston milliner. However, the profession was still alive—I was happy to meet a friend of a friend in Atlanta who creates beautiful hats all day long.

Some occupations no longer have a presence in the South, such as a bowling-alley pin handler. By the 1960s most bowling alleys had installed automated equipment that reset the pins each time the bowler knocked them over. I do know of a bowling alley in Ohio that employs a fellow who quickly resets the pins while dodging incoming balls. As much as I thought he would make for an interesting portrait, I decided I wanted to stay in the south, where one finds some of the oldest settlements.

Many other worthy professions didn't meet the paint brush simply because of my own preset limit of fifty paintings for the exhibition. I missed the fiddle makers, grave diggers, mailboat carriers, butchers, washroom attendants, bellmen, cigar makers, bridge tenders, cobblers, grist mill operators, small dairy farmers, and chicken farmers. But I am still going, so I may simply have to put more gas in the car.

I had a pretty good idea of where I was heading with my list and what kind of person I would meet—but not always. I drove around with a map and, later, a GPS device, but I didn't always refer to these. I kept working my way south until I found what I was looking for, or until it found me. Any preconceptions I had of the people in a certain industry would almost always prove to be wrong. I was continually astonished by those I met, not only by their differences but by the things we had in common.

Many mill workers I met said they knew when they were children that they would follow in the footsteps of their parents. The produce vendor from New Orleans followed the career of his father, who sold vegetables from a wheelbarrow he pushed around town. The sponge diver from Tarpon Springs followed in his forebearer's footsteps, as did the cotton picker, paper carrier, crab picker, oysterman, and pig farmer. In North Carolina I met five family members, all third generation, who worked together at a paper mill.

As teenagers few of them gave their future profession a second thought. One yarn manager from South Carolina, who had worked in the same mill for forty years, told me

he filled out a work application when he was fourteen years old. He had to wait an agonizingly long two years before he was old enough to start work.

Even after experiencing overwhelming losses that would send most people to an easier way of earning a paycheck, many workers preferred staying with what they knew. Donald, a sixty-nine-year-old shrimper born on Deer Island, off the Mississippi coast, started on his own shrimp boat when he was nineteen. In 1969 he lost his house to Hurricane Camille, and then he lost his house again in 2005 to Hurricane Katrina. I found him in the boatyard, putting a fresh coat of paint on his boat.

"It's all you ever done," he said. "You get a little thrill catching shrimp."

The love of one's work was expressed by many. A muscular sponge diver with chiseled Greek features well into his eighties waxed poetic when he described what it's like to walk on the ocean floor among magnificent sea creatures and shells.

"For as many kinds of animals there are on land," he said, " there's twice as many in the ocean. It's truly amazing. And, God, the colors!"

And a quilter from Kentucky told me, "Quilting saved my life, but it almost killed me, too."

Initially most of these people were surprised and a bit baffled that an artist would find them interesting. How many times I heard "You want to paint *me?*" What then transpired was often a bit of magic. This perfect stranger would, more often than not, be invited into a private home or place of business, be shown collections of spools or stamps or tea kettles, and have a cup of coffee or a cocktail and, sometimes, even asked to stay for dinner.

Along the way, I have made some very good friends. How often have I marveled at the wonderful life I have been given by being an artist. People have been extraordinarily generous with their time, their conversation, and, on more than one occasion, a place to stay. One doctor from Alabama was interested in my project and offered his vacation home by the river in Florida rent-free, and his caretakers introduced me to many locals and oystermen. We did all our correspondence on the Internet, and I have yet to meet him in person. Other people, some of whom I had barely met, spent hours making phone calls on my behalf, helping me find people. Doors were opened, and one conversation led to another, one life threading into another.

It was by serendipitous circumstance, for example, that that I came to meet the Hoggs. Born and raised in the mountainous upstate of South Carolina, Doug and Billie Hogg are in the business of raising things: bees, collards, tomatoes, grapes, children, you name it. If it is something that is designed to get sweeter or bigger—and to make people happy— you'll find it at their house. They'll grow it, can it, cook it, bake it, and then have the entire neighborhood over to help them eat it.

Doug Hogg is a retired textile mill overseer, and his house once belonged to the mill. He and Billie bought the house for one dollar in the 1960s, after desegregation laws came into effect and ended the practice of providing housing for a predominantly white workforce. They relocated the house across town.

"We put a glass of water on the kitchen table, moved the house, and not one drop of liquid spilled," said Hogg. A short time later, they bought an identical mill house and placed it fifty feet away from the first house. Then came three greenhouses, fruit trees, beehives, a large vegetable garden, a produce stand, and four children.

I had been hunting for a beekeeper to paint. Their daughter Jane Bechdolt comes to tend the Hogg garden every day, as well as to help with the hives and in the kitchen. The day I met the family, I asked if I could set up my easel and paint outside. I stood near a shady slope and painted a few of the pristine white beehives in the tall grass. After a while, Billie came by.

"Would you like to see the garden?" she asked. As we chatted and walked between the rows of vegetables, Billie bent down and picked asparagus, beans, and lettuce. On the way back to the house, we stopped at my easel to look at the painting. I pointed to the thin trees leaning over the hives and asked Billie about them.

"Those are cherry trees," she said. I mentioned how much I loved cherries, especially in pie. She invited me to the family noontime dinner two hours later. On the table were bowls of fresh asparagus soup, assorted vegetables and salads from the garden, flaky biscuits, honey, homemade jam, pickles, and a hot cherry pie.

And across the yard, it turned out, the Hoggs had another little mill home, sitting empty. It was perfect for a studio.

Later that summer, I rented the place and named it the "Bee House" for the ten hives right outside the kitchen window—and for the productive work I hoped to accomplish while there. The house had six rooms, unfurnished, which suited me perfectly. It was an uncluttered working environment devoid of anything but an easel, a table, a wooden chair, and necessary studio equipment. I brought my radio, slept on an air mattress, and spent twelve hours a day happily focused on painting.

Every day at precisely noon, I joined the Hogg family and an assortment of their friends and neighbors for an enormous meal served in bowls and on platters, lining up from one end of the long table to the other. My daily visit was one that I always looked forward to, not just because of the extraordinary home cooking, but also because of my growing fondness for the family. I knew the feeling was mutual the day Doug clapped me on the shoulder and said, "Mary, you all right. You just as regular as an old shoe."

Over the period of time it took me to complete this project, the Bee House served its purpose well. It was centrally located among several southern states, and it became "home base" for travels to local textile mills and later to more distant locations. The studio was also only a few hours from home and my husband, so I could easily get back when needed to the real world of the gallery, bills, laundry, family, and normal life.

Though I did many sketches and watercolor studies on location, most of the final painting was done in my Seabrook studio or at the Bee House. This was necessary because of the large scale of many works, some of which are four or five feet long. The logistics

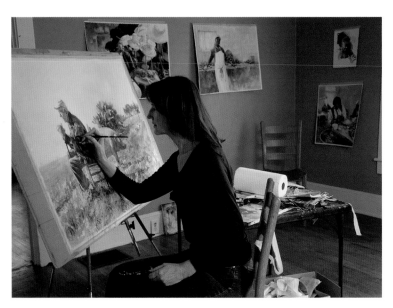

The simplicity of the "Bee House" studio was conducive to a lot of work. This is where I often painted most of the day.

Nov. 4, 2009 Urbanna, VA

[handwritten journal entry, largely illegible]

violet shirt
blue basket

have face in shadow

define light
to understate

Whenever I travel, I take a sketchbook for notes, ideas, compositional studies, and quick drawings.

of working on a big painting requires a suitable working space and an agreeable block of uninterrupted time. Many of the paintings took several days or weeks to complete. However, during these three and a half years, my time was not solely devoted to this project. I still had numerous classes to teach and a commitment to supply Coleman Fine Art in Charleston with new paintings for an ever-growing number of collectors.

There are hundreds of people I could have painted for this collection: whom to pick? Some of my choices were simply subjective. There were people I set out to paint but later lost interest, and others I didn't intend to paint, then did. Most often I looked for a profound quality, a humanness that is easily recognized and can translate into the simplest of paintings. Sometimes a friend would suggest someone whom they thought I might find interesting. In one instance my husband and I drove to eastern Texas on the tip of a friend who knew a man who refurbished old boots and resold them. She called him "a real character," and the idea of a boot man intrigued me. I pictured a fellow with skin the texture of old leather hunched over a boot, carefully replacing a heel. When my husband and I finally arrived in the dusty town and walked into the shop, I was excited to see rows of fabulous boots, all different colors of leather, some with tooled designs, tassels, and elaborate finishes. My husband was born in Texas and only too happy that day to "cover for me" and try on boots while I looked around to scrutinize the possibilities.

The owner came out with his game face on. I asked if I could take a few photos of him, and he grabbed the closest boot, held it up next to his face and gave me a huge Hollywood smile. It looked like fifty thousand watts of electricity were coursing through him as he hammed it up. He handed me a postcard, a picture of him standing in front of his shop in the same toothpaste grin, and printed in the corner was "As Seen on TV." It was all I could do to finish taking a snapshot. We thanked him and left, with an autographed post-card and a pair of boots.

I was disappointed after that encounter and vowed to find subjects who were untainted by "fame." I traveled across Virginia, North Carolina, South Carolina, Tennessee, Kentucky, Georgia, Florida, Alabama, Mississippi, and Louisiana. Although I met others who were commercially "overexposed" like the bootmaker was, I also discovered the more earnest and raw.

I had no idea when I started this project in 2007 that the country was about to tumble into one of the worst recessions in history. In 2008 news reports focused on deep rifts of change with thousands of job losses in hospitality, manufacturing, auto, and banking industries. As I traveled, the recession was both visible and palpable.

The term I used for my project—"vanishing industries"—began taking on a greater meaning as the scope of the nation's economy was affected more and more, adding to my list. Several times I stayed in hotels that had only a couple of other cars in the parking lot, in a town where many of the shop windows had been darkened. I am sure the recession colored the way I thought about my paintings.

Each frame for the works in this collection was made by hand. Smith Coleman is a master gilder and carver, and he often spends more time on the frame than I do on the painting.

For the most part many people I came to know have since adapted to different jobs or reinvented themselves, adjusting to a new world of changes. Many shrimp-boat builders now refurbish houseboats, tobacco farmers are growing organic vegetables, and sponge divers give scenic boat tours. Life has become an improvisatory art.

As a representational painter, I try to come as close as I can in my drawings to what I see that is physically before me. If my drawing is off and the nose is placed in the wrong place, the viewer may not be able to get past this inaccuracy and may fail to respond to my original concept for the painting. However, true art is not about copying. Every painting is an invention. Each painting we make is about our observation and the feeling about what we are seeing. Not one painting represented in this book is exactly what I saw, but each is exactly what I *felt*.

All the major works in the series are done in watercolor on large sheets of paper. For the most part I paint in a traditional "purist" method, meaning no white paint is used. If an area is pure white, the paper in that particular area is left blank. However, there

were several paintings where I employed white opaque gouache, such as in the sky area of the painting *Boneyard* and the background of *Pearl*. Here the milky quality of a thicker paint was just the effect I sought.

The frames that were made for each of these paintings are worthy of their own exhibition and should be noted. Each frame is completely unique and was designed and gilded by my husband, Smith Coleman, with the help of assistant frame-maker Marilynn McMillan. Some of the frames took weeks to prepare, requiring days of sanding, gilding, and burnishing. Gilding is a delicate and painstaking art, one that takes years to master, and would certainly be another vocation that falls into the category of vanishing industries. Many of the frames were carved with obvious textures or motifs to match the composition and feeling of the original painting; however, most of the creations are simple, subtly showing off their luminosity and elegance.

This series of paintings is a contemporary story told in watercolors. In a country that is focused on celebrities, wealth, and the "American Idol," these works may offer a glimpse into the world of ordinary people who might otherwise be considered invisible to much of society. It is not meant to be a series of biographies about specific individuals, nor is it meant to be a historical dissertation on industry in the South. As an artist I was never really interested in any of that. Instead, what I set out to do was show the hope, vulnerability, frailty, and determination of our unseen neighbors at work. My interest has most often been to paint people such as these, who might otherwise go unnoticed. Painting a senator may be an honor and have interesting challenges, but I would much rather paint the person who cleans the senator's office. When a person works with little audience and few accolades, a truer portrait of character is revealed.

I have chosen watercolor to tell the story because it is what I do best. I decided to focus on depicting folks plying trades that are in jeopardy instead of those which are flourishing, because I wanted to show the vulnerability we share as a people. My hope is to provide a slightly different perspective of history and, perhaps, a greater appreciation of our working neighbors. It is important to me to take what might be considered unlikely subject matter and turn it into a credible work of art. I will feel my achievement only when the cotton picker, the mill workers, and the shoeshine man look at these paintings and, through the familiar subject matter, pause a little longer to see their images as phenomena of paint on paper, as works of art.

With millions of people in the United States diligently going about their unsung work, how can we pass by as if they weren't there? In these paintings I want to show the perfect face of the uncelebrated that are all around us. To borrow from Abraham Lincoln, the Lord must love common-looking people, since he made so many of them.

Though many of the products we make and jobs we hold may have obsolescence, our spirit does not. Noted Charleston ironworker Philip Simmons was in his late eighties when I did a watercolor of him many years ago. While sketching the portrait, I asked him what he would most like people to know about him many years from now when they see his painting. His reply was simple, and it may best sum up what I want each of these paintings to say: "I was a real living person."

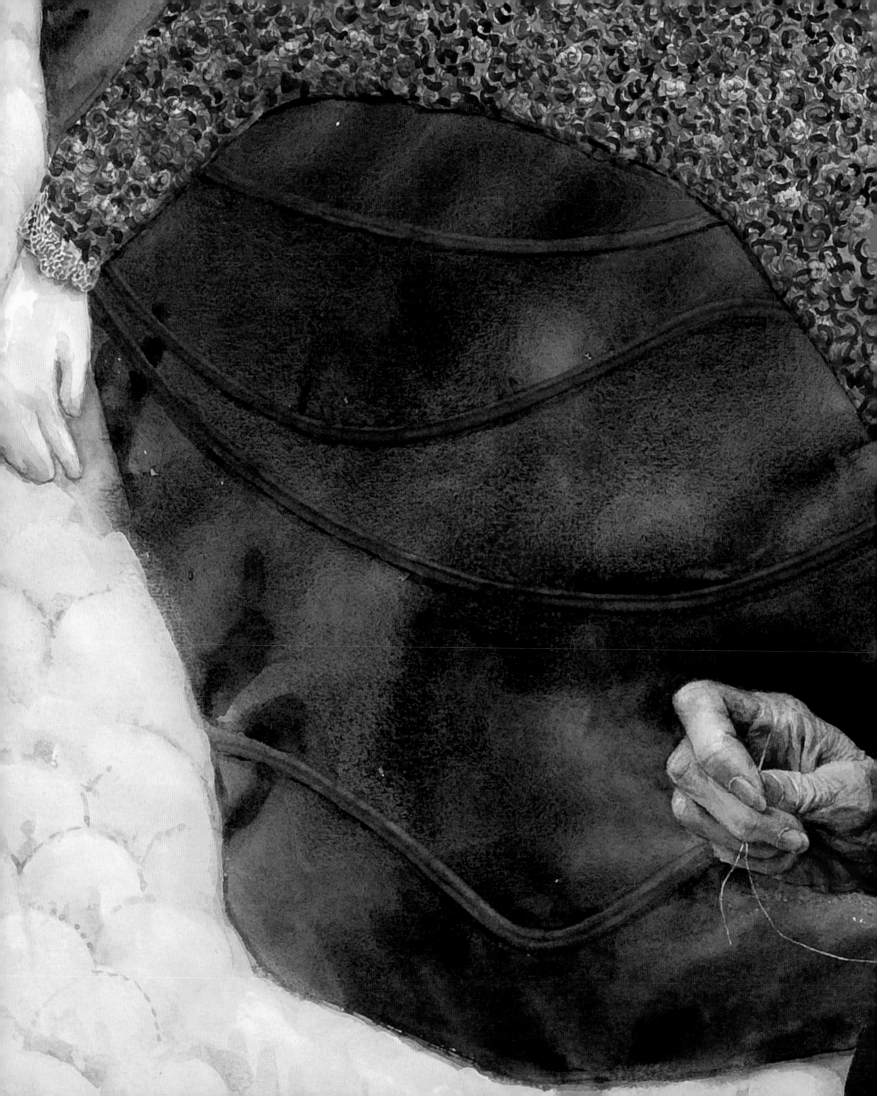

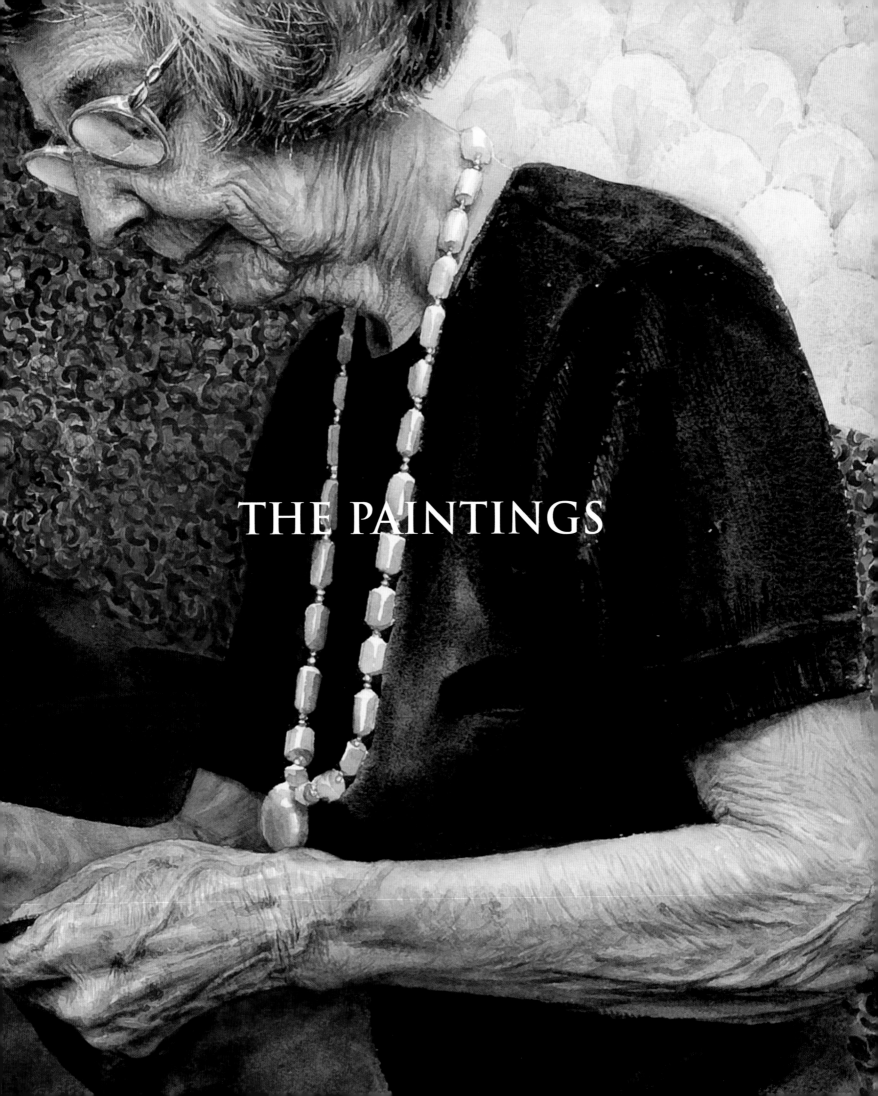

THE PAINTINGS

Spinner. Textile mill worker, Gaffney, S.C.

12

Watercolor on paper, 28 1/2 x 36 1/2 inches, 2007

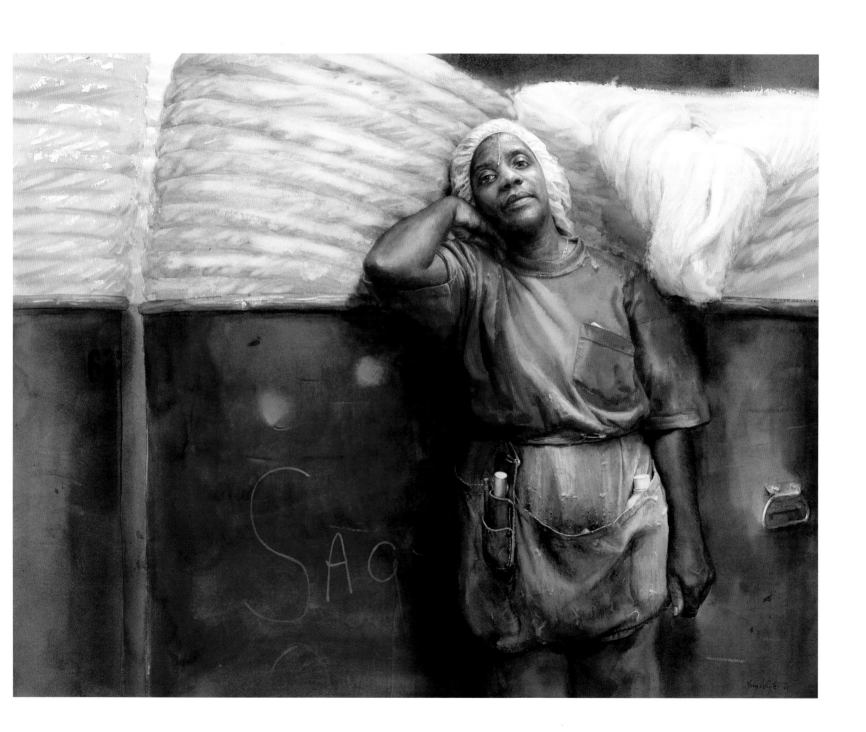

Fifteen-Minute Break. Industrial equipment cleaners, Bishopville, S.C.

14

Watercolor on paper, 58 x 38 3/4 inches, 2008

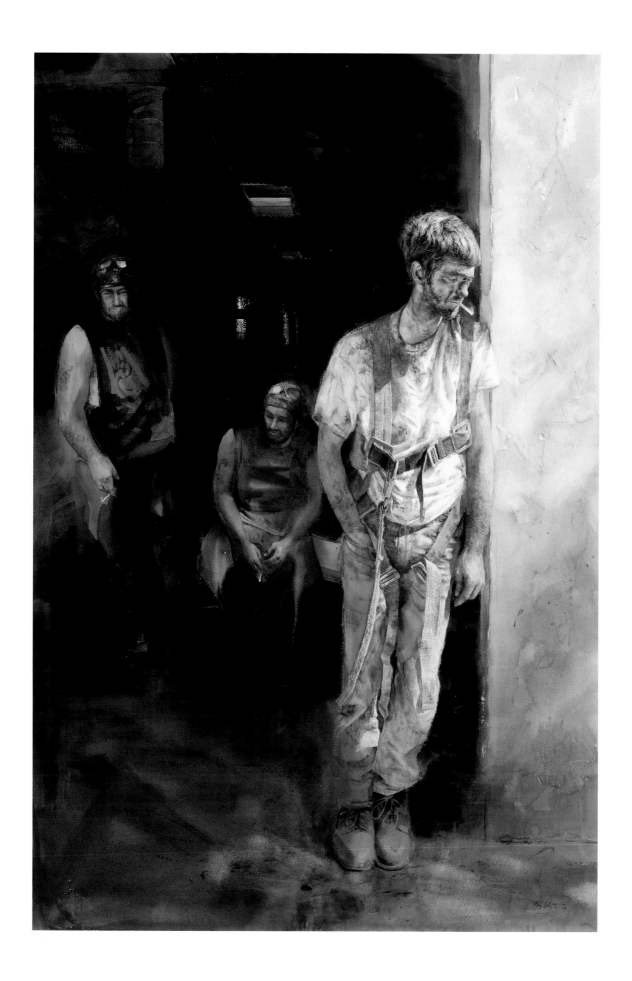

January 15
Gray Court, South Carolina

There are two hog farms left in Laurens County, South Carolina. Locals swear that the Bobo family's pork chops are the best in the state. The Bobo farm is spread wide, over a series of soft hills that join together and slope down to a pond ringed by tall trees. A gray sow with beige spots stands shoulder deep in the water, paying little attention to her offspring, who are sleeping in the dry winter grass, or to my car as it slows down at the sign for the country store.

It is a small white cinderblock building. Outside in front are two parked pickup trucks, one with a six-foot steel cage in back. I peek in the rear of the truck and see the only thing in the cage is a straight-back wooden chair on its side. I smile. They are expecting me. I glance again at the chair and notice it is identical to the one I use in my little upstate rented studio not too far from the hog farm. It's an odd thing for us to have in common.

I enter the store and see a large refrigerated cooler. Through the fogged glass, I can see trays with thick slabs of bacon, a mound of ground sausage, pink chops, and tenderloins. The whole space is immaculate and sparse: a polished floor, a rack of candy and chips, a simple Formica check-out counter by the door. In the back corner, a group of men sit in worn chairs around a glowing heater the size of a microwave. They nod to me.

I walk over and extend my hand to the one with the cane. William Bobo is almost eighty years old and, although I was told he has not been feeling well lately, clearly still keeps tabs on everything in the store. His two sons, John and Ralph, help keep the business going, including the care and feeding of seventy-five hogs and their constantly growing piglets. The men all wear caps and sturdy work clothes. Mr. Bobo is wearing a red-and-black plaid wool jacket and beige cap.

I take an empty seat in the semicircle of men, telling them about my project and asking questions about hogs.

"Are they smart?"

"Oh they smart alright," says John, tilting back on two metal legs of his chair. "They know when lightning is coming long for we do. They're low to the ground, so they feel the air turning right up through their feet." The other men nod in agreement.

Ralph is enormous, six and a half feet tall, and wide. He tells me about how almost everyone in these parts used to have hogs, feeding them big in the summer and then slaughtering them in the cooler winter months.

"Many families had a smokehouse on the property," he said, and a place to store the salty, cured pork. "Now there are hardly any hog farms left in the South."

Most hogs are now raised in the Midwest on huge tracts of land that are more like factories. No lolling around in the pond for those pigs.

I ask old Mr. Bobo about his earliest memories of the pig business. He laughs and shakes his head.

"When I was thirteen," he said, "I swapped two pigs for a bicycle."

Since then the business has grown considerably. In spite of all their hard work, they have steep competition. The megafarms can produce more and keep the prices lower.

"We're just trying to raise 'em for the price we're getting for them," Bobo says.

"If it wasn't for the store," adds Ralph, *"we couldn't make it. It's all because of the people we have coming in each week to buy."*

I close my sketchbook and ask if we can go out to see the hogs.

Mr. Bobo gets into one truck, and John gets into the other. I follow both pickup trucks a short way down the road. We stop along the side of the road on a sloped, rutted area where years of run-off have washed away anything that had ever hoped to grow. Here the fence curves away along the edge of the road, then disappears behind a knoll. On the other side of the fence are a dozen hogs, mostly sows, all milling about in the warm winter sun. In the distance I can see the sketchy lines of a fence drawn into a lazy square, with small pink ovals beneath the trees.

Holding a bag of feed on his shoulder, John swings open the gate, and we walk into the penned area. The ground feels warm in the winter sun. Tufts of dry grass cling to the churned dirt.

"Watch out for that one," John says, motioning toward the shed, where I can see the large hulk of a sow sleeping in the shadows. "She's a mean one."

A few feet away from her, two small piglets wobble into the sunlight. John tilts the bag and starts pouring the grain into a trough. A cloud of white envelopes him as hogs skirt and swirl around us squealing and scuffling, snouts and rumps colliding in the surge. I'm no farmer, but I've been to enough Thanksgiving dinners to know this is all going to be over in a minute, so I get down on one knee and start taking pictures. I am at eye level and only a few feet from the trough, and can hear the grunting and snorting and the sound of grain crunching under heavy weight. The biggest male has his front feet in the trough, and only his ears, which are as big as hands, show over the top of the bin. He roars and spins, snapping at one of the smaller pigs, which sends the rest protesting in a squall of dust. A roiling tempest of pink veers around me as each pig forces its way into the center.

In a flash I picture the absurd headline to my obituary, something surely mentioning "HOG HEAVEN," *a clip that even strangers will cut out and save. Then the storm of swine eases. Hogs start moving away, hovering together about fifteen feet from the trough. One sow backs off from the group and cautiously moves toward me, giving low wheezing snorts, wriggling her nose up to the camera lens until she is an inch away. I stand up, and she jerks back, feet kicking. She eyes me for a few seconds, then loses interest. A few smaller pigs sniff the ground, nudging the trough, checking around the corners. Most of the bigger hogs are wandering off, back to the center of the pen, loosely gathered a few feet from each other. Their feet stand on oval shadows. Soon it is quiet.*

I put the lens cap back on the camera. As if coming out of a dream, it takes me a second to remember where I am. John is over by the truck, folding something up and putting it in the back. I turn around. Mr. Bobo is sitting on the wooden chair facing away from me. He is motionless, his papery hands folded on top of his cane, his back barely touching the chair. His large brown shoes sink ankle deep into the grass, and the sun sits in small triangles on his nose and cheeks. He is squinting slightly, staring out over the pond at something way in the distance.

Sentinel. Hog farmer, Gray Court, S.C. Watercolor on paper, 28½ x 34½ inches, 2010

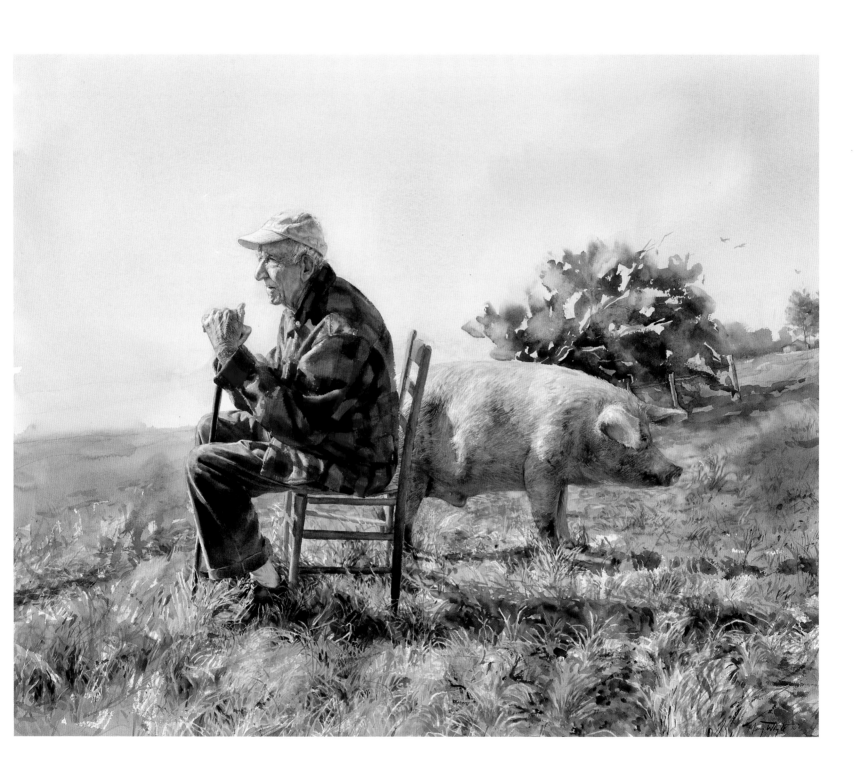

New Year. Milliner, Atlanta, Ga.
Watercolor on paper, 22$\frac{1}{2}$ x 29 inches, 2009

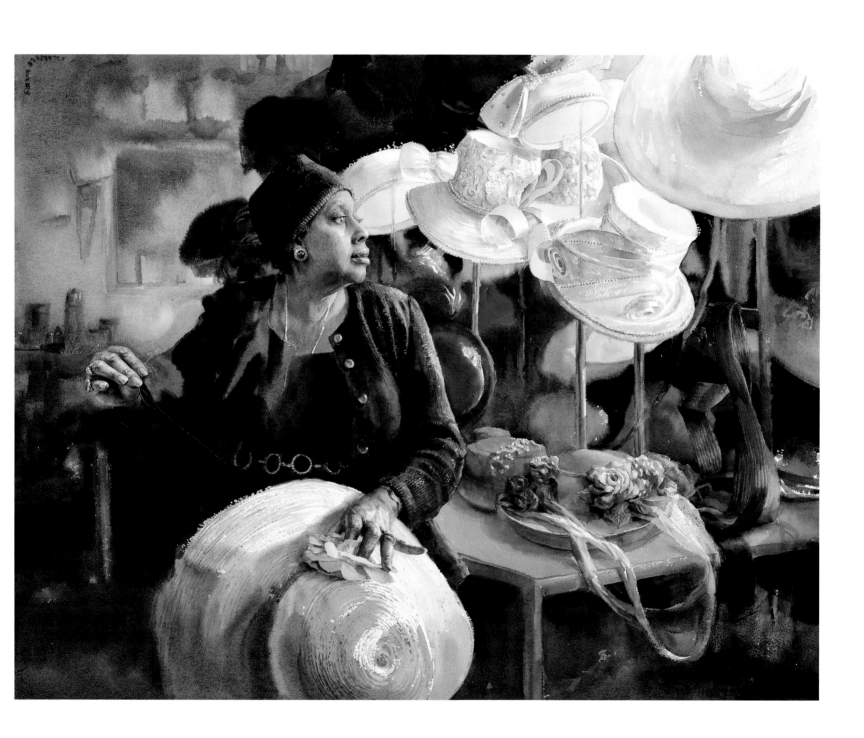

Mr. Okra. Produce vendor, New Orleans, La.

Watercolor on paper, 28 1/2 x 38 1/2 inches, 2008

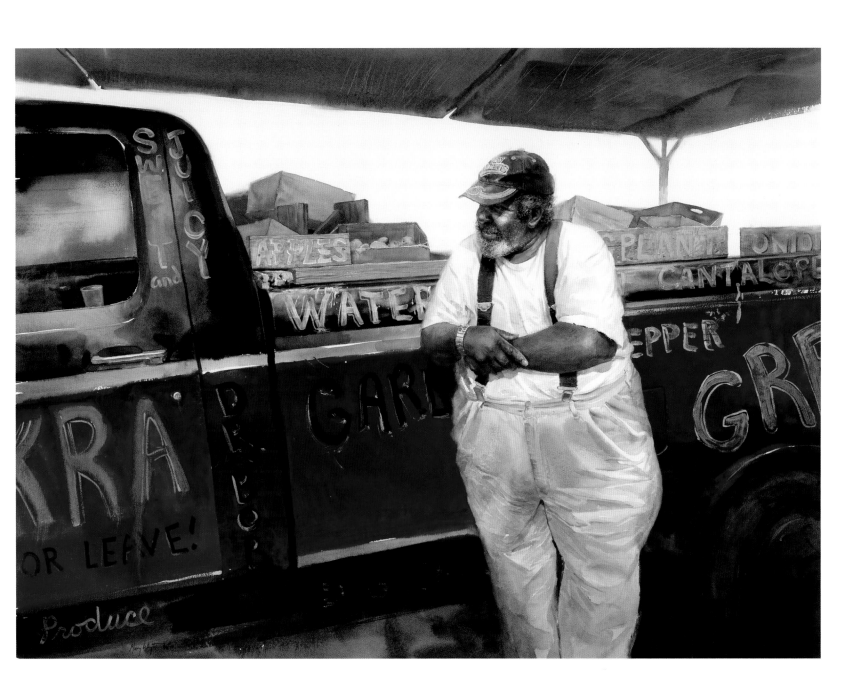

Lovers. Quilter, Berea, Ky.
Watercolor on paper, 26 1/2 x 27 1/8 inches, 2008

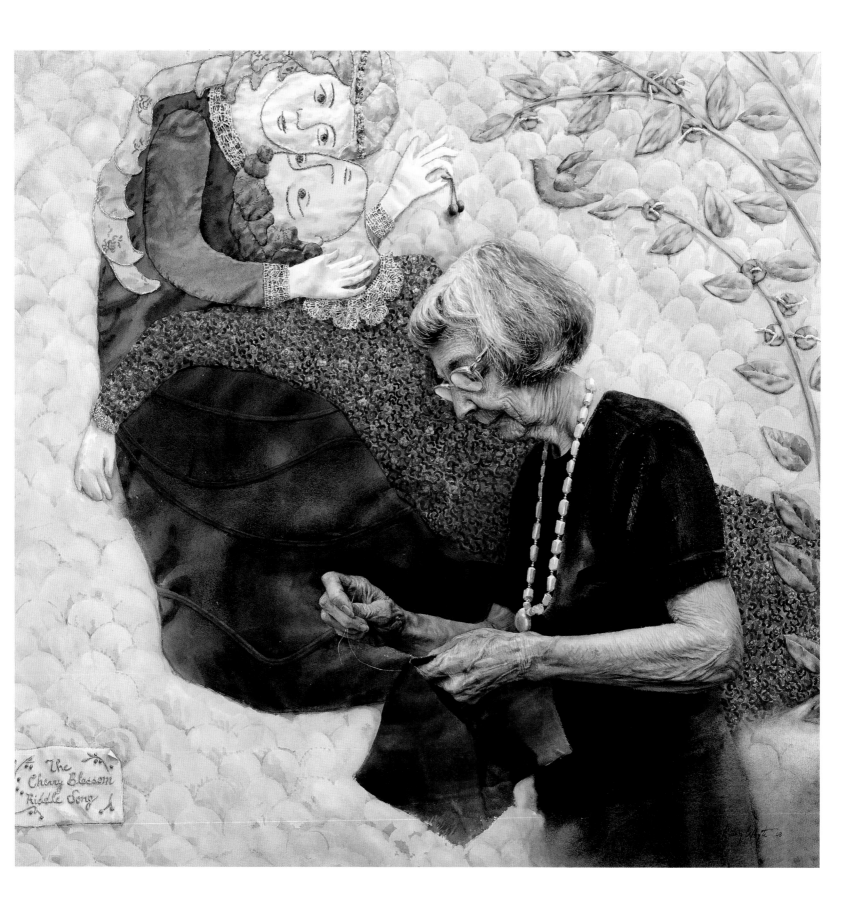

February 23
 New Orleans, Louisiana

The apartment we have rented for the month vibrates, shaking the Mardi Gras beads looped around our second-floor balcony. Cars cruise below, pulsating with loud, deep rhythms that make the leaded glass windows buzz. If I lean over the railing far enough, I can see a river of people on Bourbon Street. Below two men in gray suits tap their oversized plastic wine glasses together and laugh. It is early morning.

I take the stairs to the street and thread my way toward Canal Street, stepping over discarded cups and puddles of frothy, foul-smelling liquid. Vendors wearing Dr. Seuss hats and layers of silver chains hold up souvenirs. Rap music spills out the door of a club. In the window is a large black and white photo of two young women kissing and an advertisement for free food with the cover charge. On Canal Street the street cars grind and clang as I push open the brass revolving door and enter the hotel lobby.

I take the escalator to the second floor, where the plush carpeted hallway is lined with ten-foot-high gilded mirrors, and there are two oriental urns that hold cascading floral arrangements. I spot him, sitting up on the tufted leather bench, head tilted slightly to the side, looking down at his newspaper—probably the sports section, which is his favorite, next to the comics, which he copies onto sheets of white typing paper when business is slow. Under his bench he has stored a lot of his own drawings. He is wearing a perfectly pressed white shirt and crisp black apron. I wait to see if any customers come by to ask him for a shoe shine. Mr. Noah turns the page.

We had met three days earlier, when I had asked him if I could do some sketches of him. I set up my easel and did a quick watercolor sketch while we chatted. Fast-paced businessmen with their heads down skirted around me. One man finally stopped and stepped up to sit on the high-backed bench, talking on his cell phone while Mr. Noah brought the man's shoes to an ebony mirror shine.

I watched the precise rhythm that the grey-haired man in the starched apron used. The same rhythm he has used since he was five years old: buff, snap, buff, snap, buff, snap. The customer reached into his pocket, still talking on his phone. Buff, snap, buff, snap, buff, snap. Seven dollars.

Today business is especially slow. When he sees me coming, Mr. Noah turns and greets me, extending his hand in a warm welcome. "My artist friend," he calls me. He shows me his latest pencil drawing, Garfield the cat.

We stand at the window and enter into comfortable conversation. I ask him about his life and what it has been like living in New Orleans. He tells me about how Hurricane Katrina had displaced most of his neighbors, how many had lost their homes either to flood or to unscrupulous financial offers afterward. His own business had been slowly tapering off long before the storm, a by-product of our throwaway society. Instead of shining and repairing our shoes we shed them and buy replacements. But now jobs are even spottier in New Orleans, and crime is way up, with the city struggling to pay a threadbare police force. Many of the well-paid professionals have fled the city, taking with them shoes that need shining.

"The worst part," said Mr. Noah, "is people don't care how they look." People seem indifferent to many things. People don't seem to care much about anything.

"Why do you stay?"

Mr. Noah became silent and continued to look out the window. Across the street the building was festooned with a three-story banner showing the face of a beaming African American basketball player. He carefully folded the buffing rag into four equal rectangles.

"Come," he said, placing the soft fabric inside a cubby hole under the bench. "I'll show you."

I followed Mr. Noah to the elevator, which we rode to the top floor. The elevator door opened, revealing a hall with only a few lights on. We pushed open a metal door marked "EMPLOYEES ONLY" and entered a large kitchen. Carts with coffee pots and stacks of white plates were lined up in rows. Heavy stainless pots hung over empty stoves. In the dining room the chairs were turned upside down and set on the smooth, round tables. Large windows flanked with thick, green curtains pooled light into the room from three sides. Mr. Noah pointed toward the windows.

I stepped up close to the glass and looked out. Far below us, fanning out for miles, were hundreds of peaked roofs, narrow streets, and low slung warehouses stringing into the distance. Rail lines crisscrossing between cemeteries and parks met at the horizon beneath a pewter-colored veil. I could see Jackson Square and the spire of St. Louis Cathedral, echoed with the repeated vertical lines of a dozen other steeples. The wide "U" of the river, a hammock made of silver and clouds, funneled miniature tugboats and freighters, leaving behind the delicate imprint of a comet's tail.

Somewhere below us a musical note tentatively reached up, then was folded into a bird. Mr. Noah stood straight, looking out the window with his hands in his apron pocket.

"That's why I stay," he whispered.

Shoe Shine. Shoe shine specialist, New Orleans, La. Watercolor on paper, 25 ¼ x 23 inches, 2008

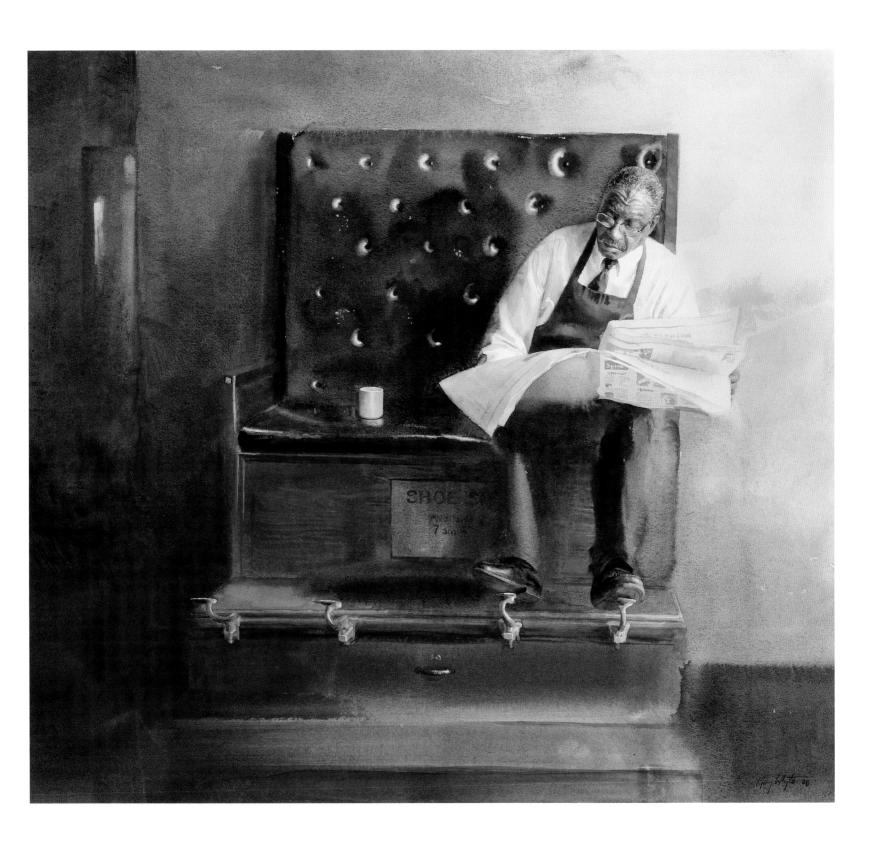

Abyss. Sponge diver, Tarpon Springs, Fla.
Watercolor on paper, 30 3/4 x 23 1/4 inches, 2009

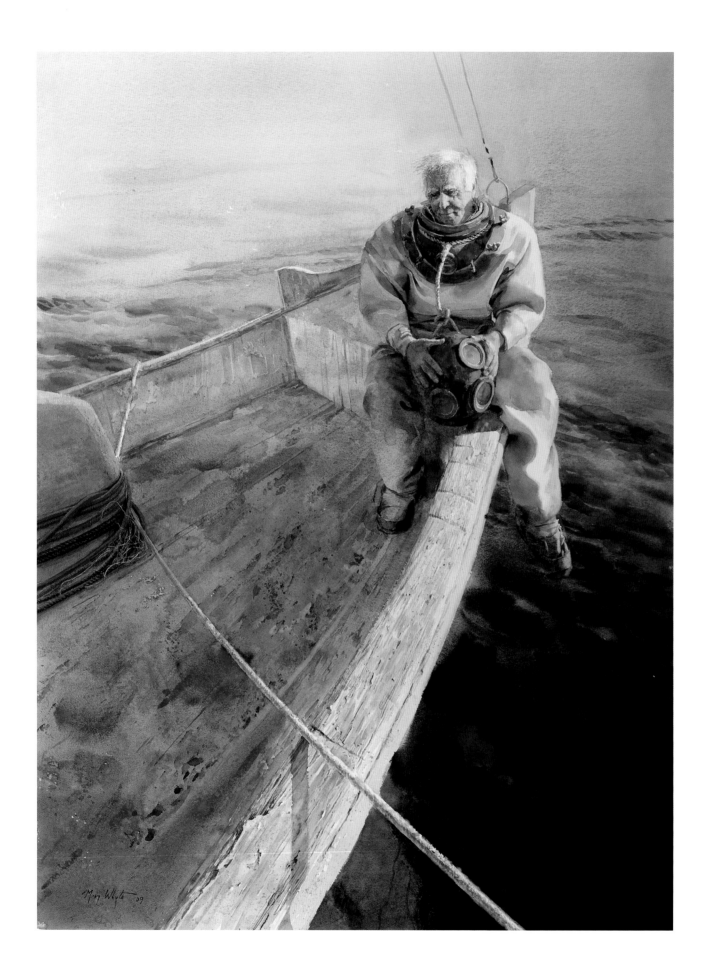

March 5
Easley, South Carolina

I am in a textile mill, following two men with badges and clipboards. They are wearing neatly pressed button-down shirts, khakis, and beige shoes. One of the men's shirts has a perfect horizontal crease where it was newly unfolded. I am wearing jeans and sneakers and plastic goggles that keep sliding down my nose. Under one arm is my faded red sketchbook, covered with spatters of blue paint, and a droopy canvas camera bag. I keep my head down, focusing on the convergence of metal rails and slicks of oil, while constantly glancing up at the beeping sounds and moving machinery around me.

Please, God, I think to myself, please don't let me slip and look like an idiot.

I move faster to keep up, while nodding at a man checking a row of valves. Over each panel in front of him are amber-colored dials. His loose jeans are weighed down on the side with a thick leather tool belt. One of the clipboard men turns to me, his mouth moving, hand gesturing toward the row of glowing lights. He points to a woman in a white shower cap. Through the gauzy fabric I can see a long, silver braid coiled in years as she watches a wall of jumping, vibrating threads. It looks like a white waterfall. I nod, smiling, and jam my finger back into my ear, playing with the squishy earplug. All I can hear is a tornado in a soup can. I want to ask a question and then remember the men's instructions not to attempt to talk "over" the noise, but to lower my voice in order to be heard. Right.

One man's mouth does a series of crumples, and I look over his shoulder and see a woman with dark hair—the color of lava—tucked into her shower cap. She is running her fingers over a bank of white threads like the strings of a harp. She pauses to look up at a clock on the wall, then runs her veined hands again over the threads, her flat palm hovering just above them. She is wearing a smock printed with geraniums and little watering cans and also a plastic name tag I can't quite see. She steps to the left, into a narrow shaft of light, which falls over her shoulders and illuminates her face inside a halo of fiery white. I inhale. One of the talking clipboard men pauses. He follows my gaze toward the woman, then past her. He resumes talking and walks on.

By a Thread. Textile mill worker, Easley, S.C. Watercolor on paper, 27 3/4 x 39 3/4 inches, 2006

32

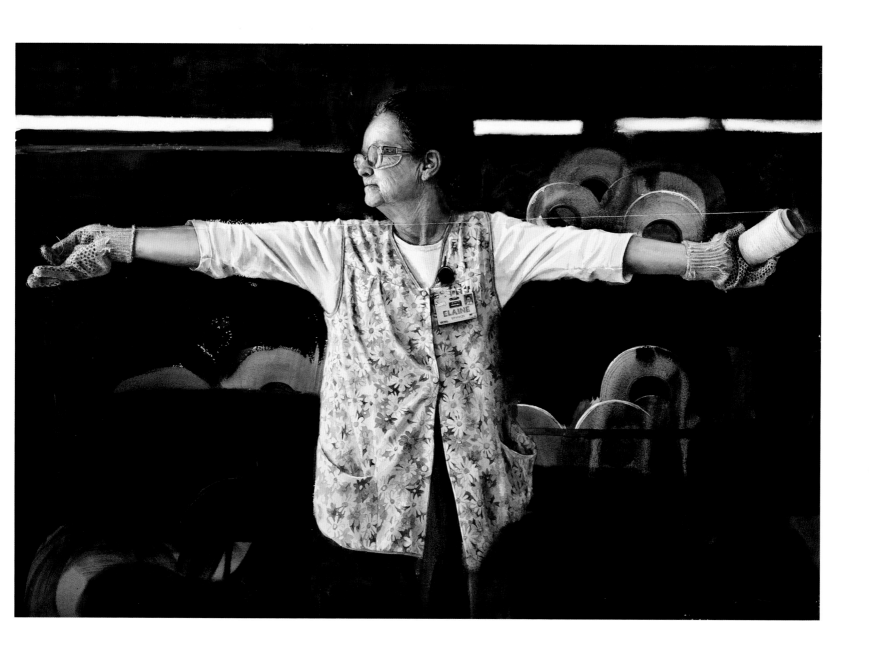

Tips. Diner owner, Bishopville, S.C.

Watercolor on paper, 22 $\frac{1}{2}$ x 30 $\frac{3}{4}$ inches, 2007

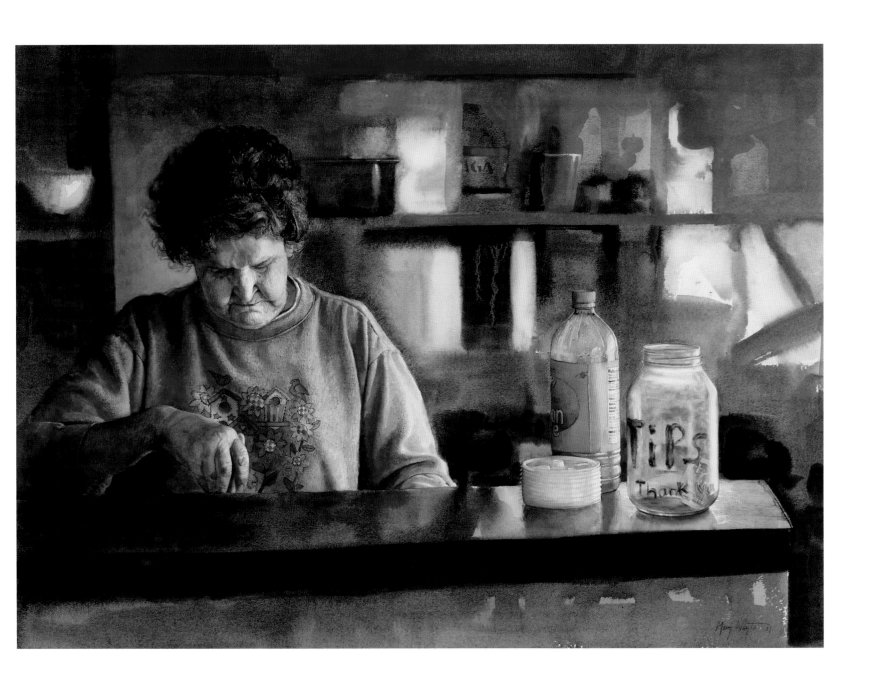

April 4
Jamesville, North Carolina

I had heard there is a river in the eastern part of North Carolina that in early spring turns the color of coffee and cream, its banks once lined with dozens of ramshackle fish shacks. When the river was swift with melted snow and spring rains, the "cook-up" shacks opened. Dressed in knitted hats, mittens, and rubber boots, the locals cast thick nets between the water's muddy banks, in time for the thousands of silvery herring which surge up the river to spawn. The annual herring feast is the one golden thread of memory the locals proudly share.

Today there may only be one shack left. I don't know for sure. I try the phone number, and there is no answer. It is almost Easter, and I have read that the harvest is only from January through April. So I get in the car and go.

I leave home while it is still dark, hoping to arrive in time for lunch. Jamesville is a small town off the highway; it has two stoplights and is squeezed in between great fields of sur-rounding farms. There is not much to mark one's arrival. A church, a few houses, and a store that has caskets for sale. The flat, narrow roads outline the square fields, converging at an occa-sional stop sign. In the backyard of one house, there are blue sheets hanging out to dry.

I follow the road toward the woods. The road curves through the trees, then down a slop-ing embankment, where it dead ends at a half-filled parking lot and a concrete boat ramp. Through the barren oaks and poplars, I see a wide ribbon of cream-colored silk, the Roanoke River. And there stands a shack with weathered board-and-batten cypress under a silvery tin roof.

Inside, stark white tables are covered with blue-and-white vinyl tablecloths. It is one o'clock, and I am in time for lunch.

Leslie and Sally Gardner are in their seventies and have been married thirty years. When their sons were young, they would net herring each morning before school. These days Leslie drives to the city to buy herring that has been imported from South Carolina. Local herring is banned because of overfishing. Leslie comes in the kitchen, carrying a plastic tub on his hip that is filled with fish, minus their heads. They have slits scored through their thick skin, which makes for easier cooking.

The dark-haired woman dips each piece of herring in flour and slaps it on its side before immersing it in a pan of hot oil. A small window with a shutter that opens inward pulls the circles of steam away from her face and out toward the river. A young girl stands next to her on top of a plastic crate, reaching into the deep metal sink. The fry cook hands her a pan to dry.

The menu is

River herring $5.
Herring and roe $7.
Chocolate pie $1.
Boiled potatoes, cole slaw, hush puppies.

I take a booth near the window. A few customers talk with the waitress. I ordered fried her-ring, which I eat with my fingers. In the bite I taste the brine with a powdery crunch; it has the insistence of spring.

In the kitchen, three generations stand hip to hip next to the sink, talking and laughing. Chocolate pies are stacked on shelves near the pass-through window.

Outside the river slides past silently. Spindly young trees tentatively fill in the level places along the slippery banks, erasing the boot prints of many lives.

Roanoke. Fish-shack
operator, Jamesville, N.C.
Watercolor on paper,
28¾ x 26¼ inches, 2007

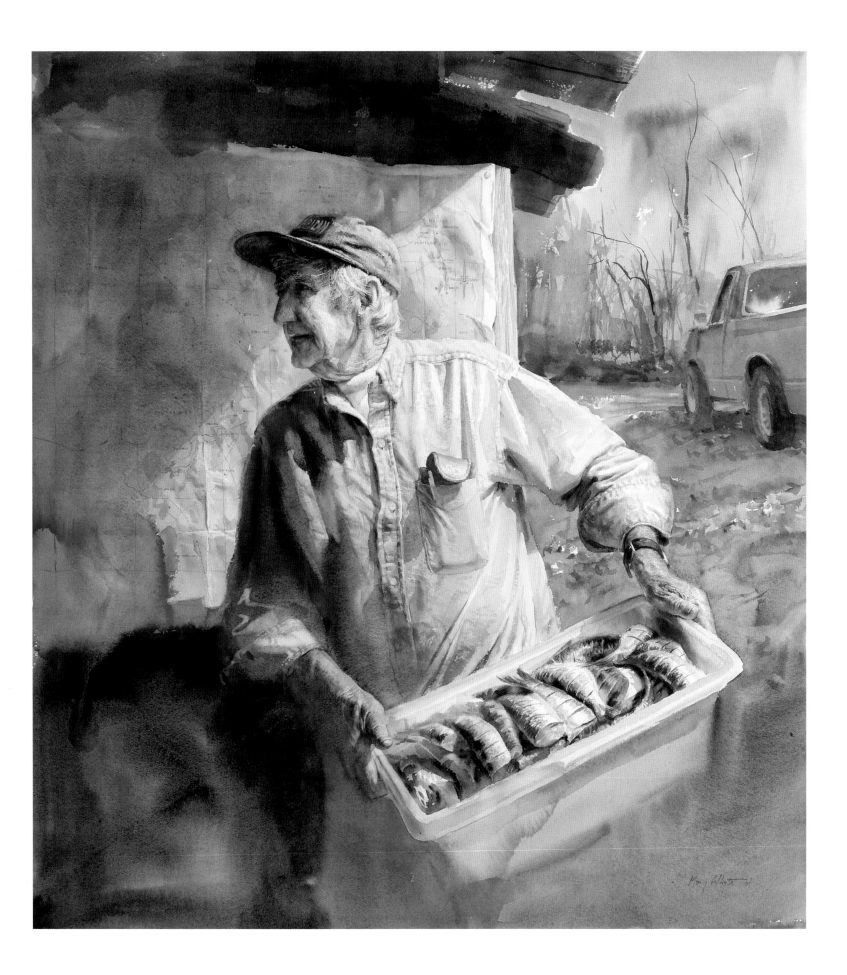

40 *Shroud.* Textile mill worker, Gaffney, S.C.
Watercolor on paper, 58 x 36¼ inches, 2007

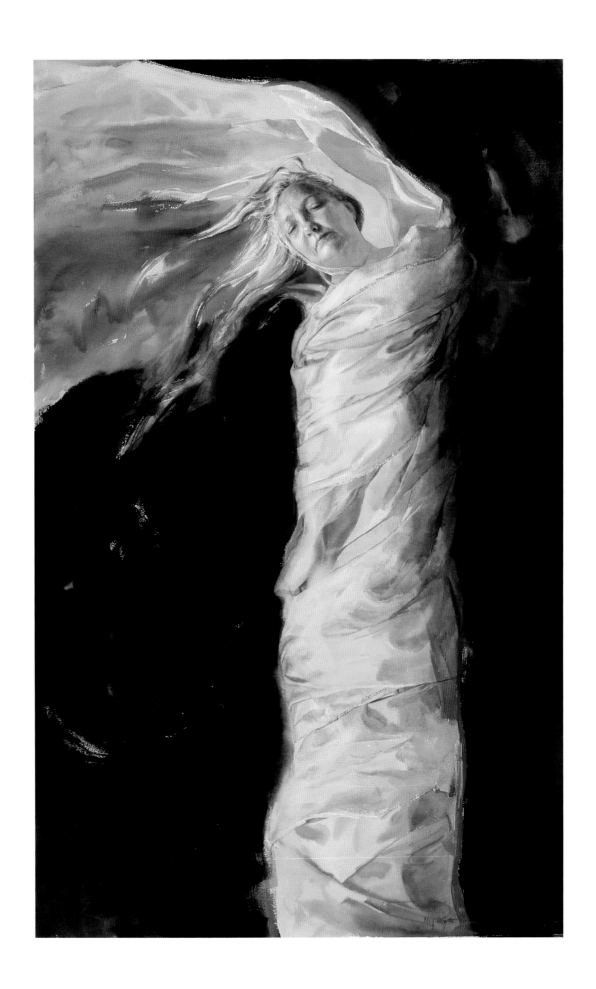

Night Light. Drive-in movie operator, Lewisburg, Tenn.

42

Watercolor on paper, 28$\frac{1}{2}$ x 28$\frac{1}{2}$ inches, 2009

Mary Whyte '09

If I had been here before Katrina, I might instead be painting a grand antebellum house. I might also have found the town teeming with shrimpers and boats.

In the boatyard I can hear scraping as men work under the hulls of wooden boats raised up on webs of scaffolding. At 6:30 in the morning, the sky is pale pink. I speak with a few men as they use their brushes on the wide belly of a fishing boat. One of the guys growls directions to the Main Street Harbor. I couldn't find it before because it is behind one of the giant casino buildings. I finally find the casino at the end of Main Street and park in the empty side lot, with spaces marked for hundreds of cars. I can see the masts and looped nets of a half-dozen shrimp boats bobbing in the marina.

The closest vessels are the sleek, recreational fishing boats. I am relieved to see the shrimp trawlers have not yet gone out; they are still moored at the far end of the piers. The dock itself is a jumble of broken concrete slabs that were shuffled and tossed up by the hurricane like a deck of cards. In between the gaps of upended concrete, I can see the olive-colored water sloshing eight feet below me. On one old boat a Vietnamese family is cooking breakfast. I see laundry hanging inside their tiny cabin. I crab-walk my way down to the end of the dock to where the men at the boatyard have told me I can find Eddie.

He is standing in the cabin of his trawler, surrounded by tools, coffee cups, and empty to-go boxes strewn all around him. Two wooden bunks are covered with greasy engine parts, and a tangle of electrical cords snakes across the floor and out the door. In the corner there is a bucket with a toilet seat balanced on top, which I correctly guess to be the on-board amenities.

I am glad that I haven't missed Eddie and that he is still readying his boat for the season. He wipes the black grease off of one hand onto his blue denim overalls and extends it to me in welcome.

"Hello, Miss Mary." A barrel-chested father of five, Eddie is happy to talk about his work and allow me to take some photographs. He moves about the boat easily, showing me the huge nets, raising and lowering them with powerful arms.

"My first boat was 18 feet and made of plywood," he grins, obviously proud of his current vessel. He, like many before him, has endured the physical trials that come with the territory: a finger severed in a winch, broken bones, and even gunshot wounds (I didn't ask for the details). In spite of the injuries, Eddie still loves "the catch."

He told me that he goes out mostly at night, with his eighteen year old son as crew. They seek out good places to drag the nets for a few hours, checking the "try" nets every fifteen minutes for shrimp. A thousand pounds of shrimp is a good haul.

"This isn't meant for everybody," Eddie says as he coils up a thick rope. "It's a challenge. You locate the shrimp. You catch them. The best part of the job is no one can tell you when to come and go."

Still, he realizes he is one of the lucky ones. After Katrina the local shrimping population was depleted almost by half. Many lost their boats in the storm. Others simply gave up the business, as foreign competition, rising fuel costs, and dull economy were too much to endure.

45

We go inside the boat so he can show me the navigational devices. Over the wheel, above the blinking lights, log books, and repair manuals, I see a small framed picture under glass stained with mildew. I can't see the image but can make out two words: "Perhaps Today."

"It's always been there," Eddie says, standing in the doorway. "Come with the boat when I bought her, and it'll go with her, one day, when I sell her."

"Perhaps Today." I wonder if the phrase means that maybe today there will be a big catch, fair weather, or a winning lottery number, or maybe the price of gas will go down and the price of shrimp will go up. I put on my glasses and peer closer. Beneath the words is an image of two figures, faded and barely visible. It shows a fisherman, his face looking ahead, determined, wearing a yellow rain slicker and standing firmly with both hands on the wheel. Standing behind him, barely visible, is the soft, glowing image of Christ.

"Lot of shrimpers have that picture in their boat," Eddie said. I wonder to myself if the fishermen believe in Jesus, or the men feel that having the picture is like chicken soup or a rabbit's foot. I nod. I figure that fishing is a tough enough business, and that either way a little hope can't hurt. No one knows for sure if the picture works, but they aren't going to take a chance otherwise.

Later that day, I am painting in a vacant lot, standing in knee-high grass where someone's house once stood. One concrete step remains, like a dog waiting for its owner. Across the road white sand stretches in both directions, starkly bookended between two soaring hotels. They are giant buildings containing muggy spring air floating in the gap where another hotel once stood.

My subject here is the mobile home, strung along a low dune like a string of burned-out light bulbs. The late afternoon sun reflects on the tin roof like a mirror on a blaze.

Trawler. Shrimper,
Biloxi, Miss.
Watercolor on paper,
37 x 28 3/4 inches, 2009

46

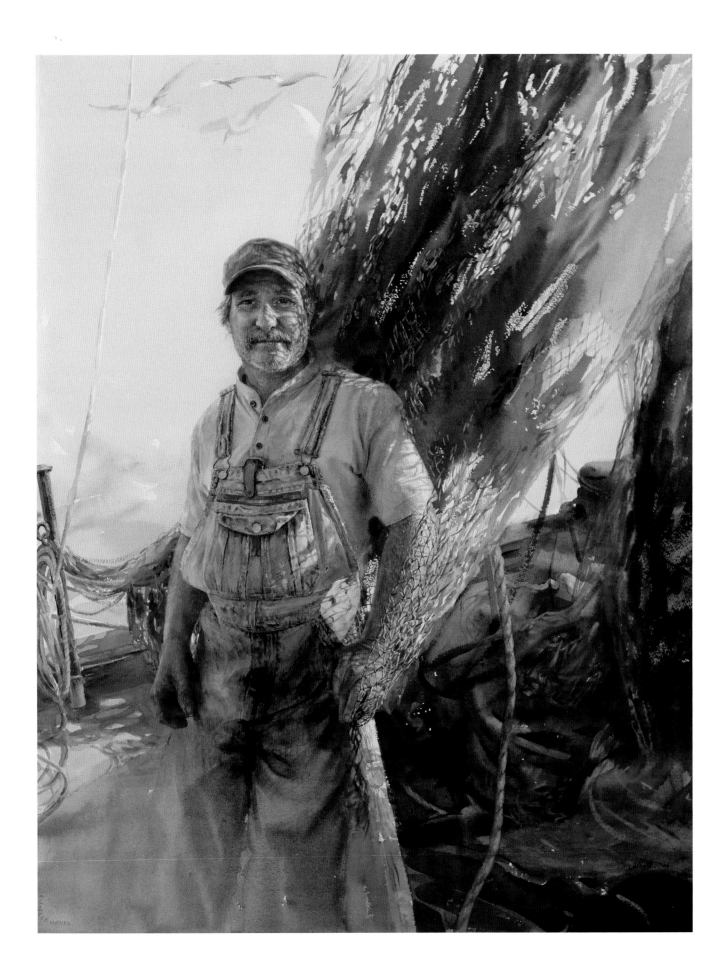

48

Disciple. Crab picker, Hacks Neck, Va.
Watercolor on paper, 21¾ x 19¼ inches, 2009

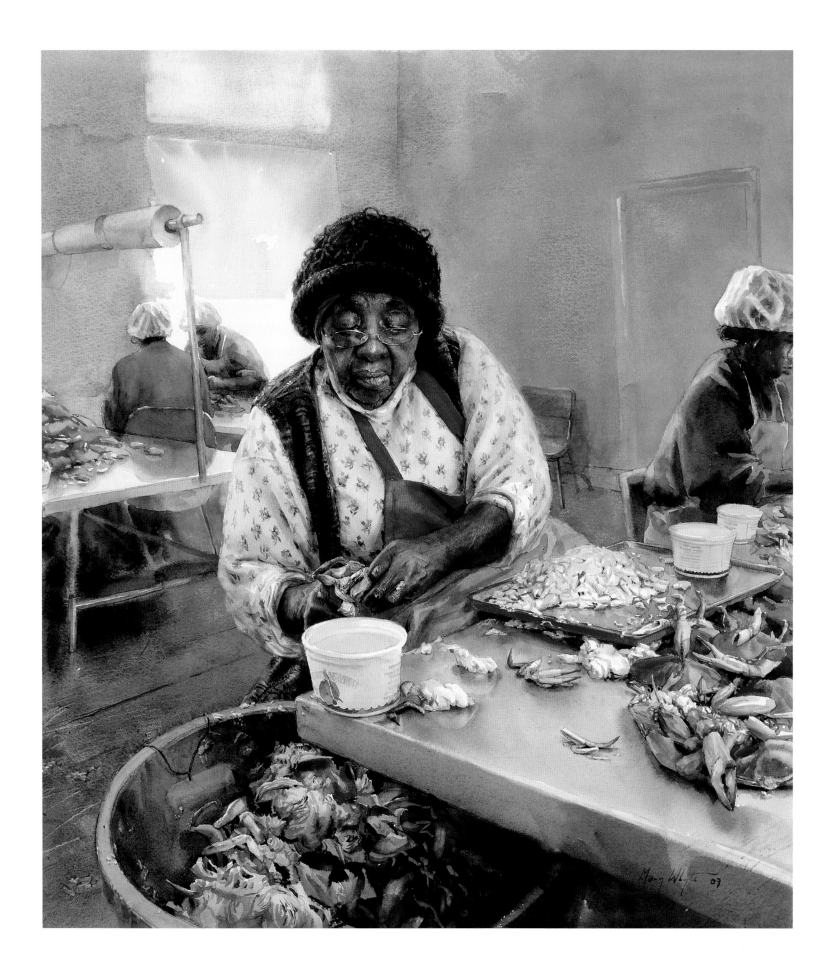

Trap. Crabber, Pinpoint, Ga.
Watercolor on paper, 30 3/4 x 38 1/8 inches, 2008

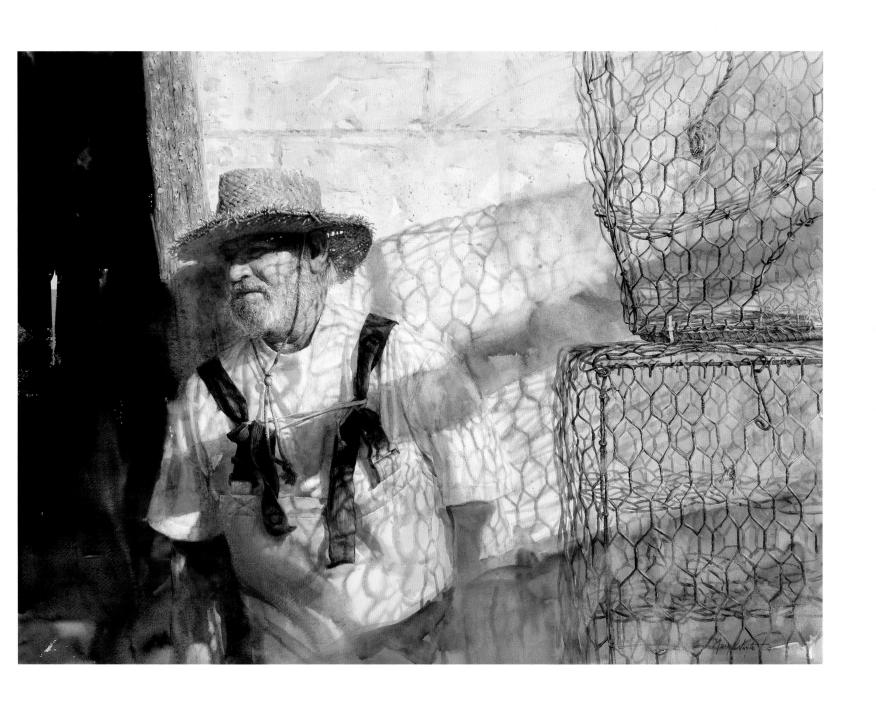

I am on a steel catwalk. Twelve feet below me, behemoth logs are being catapulted through a shoot and into steel jaws that strip the trees of their bark and then rough cuts them into boards, sending out showers of sparks. Heavy planks pound against one another fiercely, jostling up a conveyor belt. A man in a hard hat and heavy boots agilely steps between the tumbling boards, prodding them with a long hook.

I am wearing the white hard hat like everyone else has, though I have on the wrong shoes and clothing so I can't pass as an employee. A few workers glance up as I follow the men on the catwalk, and they wave to us. Scotch Lumber Company is a small family-owned sawmill, operating now for more than a hundred years. The office walls are lined with sports trophies, get-well cards, and faded photographs of family and employees. Tony, the manager, calls something down to one of the men. The worker checks his watch, nods, and gives a thumbs-up. George Williams, a soft-spoken employee of forty-four years, is behind me and waves at the man.

I follow the men outside, where it takes me a few minutes to adjust my eyes to the sunlight. Here, huge trucks grind gears, spewing clouds of white dust as they back up their freight to the unloading area. The clawlike bar on the side of a truck releases its grip and an avalanche of logs spill out. The logs are funneled into a line and shoved before a guillotine, a mighty six-foot round saw blade on the end of a long arm. It lowers, swiftly slicing through the trunk. The saw lifts, and a conveyer carries the massive column up and over the parking area and into to the mill.

"This is it," I say to Tony.

He turns to me, tapping his ear.

I shout a second time, gesturing my arms wide into a circle and pointing up to the whirling saw blade. Then I motion to George Williams. Tony nods and disappears up the wooden steps to the elevated control booth.

Earlier that morning I had told Tony about my desire to paint a long-time employee from the lumberyard. He had suggested Williams, an ebony-skinned, soft-spoken man who worked as an edger. I wanted to find the right setting, one that exemplified the dangers of the job and contrasted with the demeanor of the subject.

This place is perfect.

I can see Tony through the window, talking to another man, motioning to the saw and then to me. The manager brings his thumb and forefinger up to his face in a C like he is holding a camera.

The screeching of the saw abruptly calms to a whirring, and then the blurred edge of the circle stops to reveal the jagged teeth of the enormous blade. I can hear machines cutting off all the way down the line, as the moving logs slow and then stop. The mill is silent.

I explain to George what I have in mind and he nods. We clamber up a mound of wood chips, our feet and arms swimming furiously as the bits of wood push away beneath us. George finds a place near the top. I study his pose for a moment, then change the position of his arms. It is very hot, and sawdust clings to my bare arms. I ask him to look in the other direction, out over the storage sheds, but it still isn't quite right.

53

"Would you mind sitting closer to the saw?" I ask. The lumberman nods and scoots up farther, as far as he could. I adjust the setting on my camera and motion to his hard hat, which he quietly removes and places next to his feet.

Above him is the mighty saw, hovering on a raised arm at the ready. The jagged teeth are poised just a few inches from the crown of my model's head. I take the picture.

The man never blinked.

Edger. Lumberyard
employee, Fulton, Ala.
54 Watercolor on paper,
22 x 30 inches, 2007

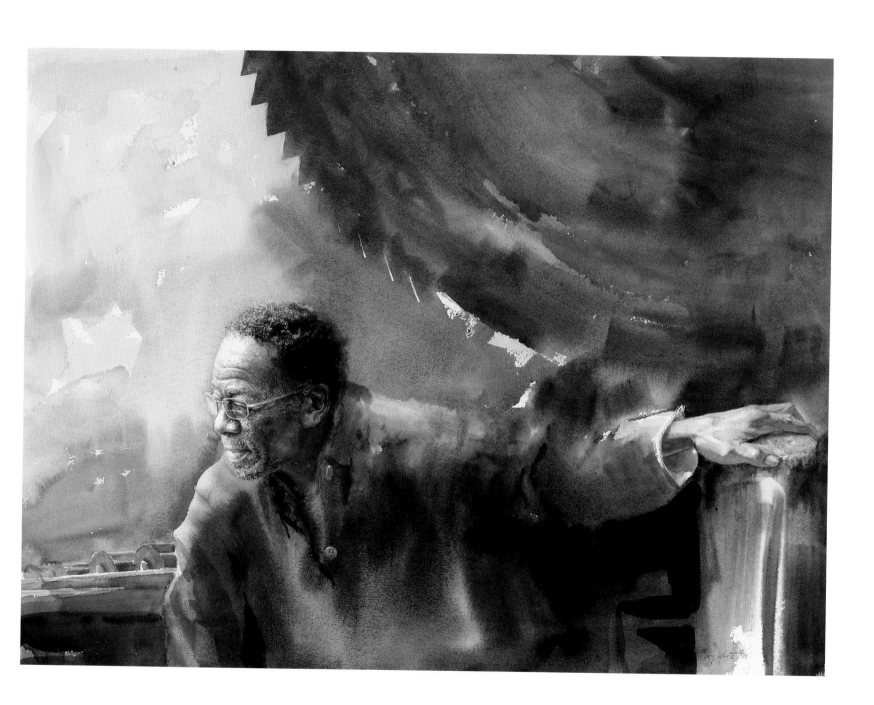

56

Fried Herring. Cook, Jamesville, N.C.
Watercolor on paper, 27 x 21$\frac{3}{4}$ inches, 2007

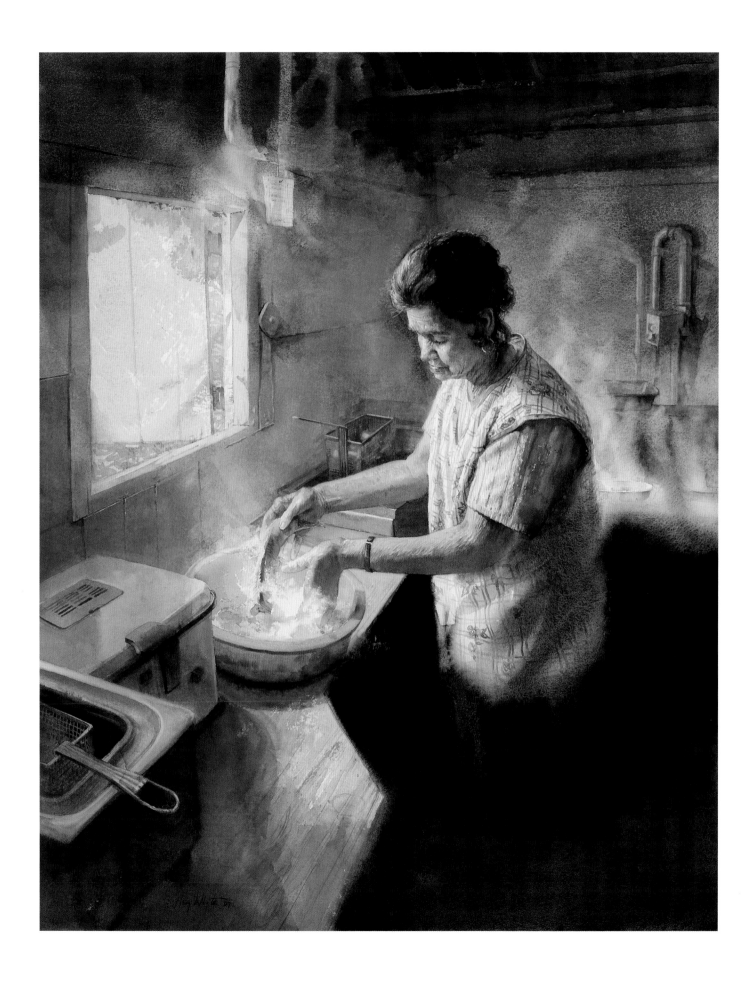

58

Boneyard. Textile mill worker, Greenville, S.C.
Watercolor on paper, 18 3/4 x 28 3/4 inches, 2009

August 1
Union City, Tennessee

Union City is in the very northwest corner of Tennessee, near the Mississippi River. It is laid out in short blocks, with modest homes set close to the street, framed with neatly trimmed shrubs and small porches punctuated with American flags. In the center of town is Main Street (of course), a few offices, shops, and restaurants. Railroad tracks bisect the town. I spend the early afternoon in a buffet pizza place eating three different kinds of pizza (research, you know), and studying the Messenger, *the local newspaper. It is the reason I came to Union City. I am filling time before meeting with my model, a fifteen-year-old paper carrier.*

The paper is delivered in the late afternoon, by no later than 5 o'clock, so the presses usually start running in the early afternoon. Kelly Hendon, the carrier, loves music, and he spends most of his free time playing bass guitar with his school friends. But after school he goes directly to the warehouse where the printing presses are. He is accompanied by his friend, twenty-year-old Jon-Tyler. The two young men stand side by side, first rolling the papers and then inserting each one into a plastic sleeve. They do this every day except Saturday and Sunday, and three holidays: the Fourth of July, Thanksgiving, and Christmas. The day after Thanksgiving, Black Friday, has the fattest paper of the year, because of all the ad inserts. It is also the longest delivery day of the year.

Inside the brightly lit printing house, there is the strong smell of ink and paper mixed with the crushing sound of presses churning, stamping out newspapers. The smell is familiar: a rush of memory comes to me. In high school I had also worked after school at a newspaper, laying out ad graphics. I had forgotten until I smelled the ink.

Lines of newspapers trudge their way past the various colored-ink barrels in a circuitous route that looks like the tracks of a roller coaster. Several men monitor the moving line of papers closely, making sure the registration is exact. In another part of the plant, one man is hunched in front of computer screens, a phone to one ear. It's impossible to hear him over the roar of the press, and I wonder how he can hear his phone caller. In the very back of the warehouse is a cavernous room filled with mounds of printed papers, strapped tight and headed for the recycler.

Kelly Hendon was born into the business—the newspaper has been in his family for thirty-nine years. He has been delivering the Union City Messenger *since he was six, at first helping his older brother, who is now in college. Kelly's father delivered the paper on a bicycle when he was a teenager.*

Most copies of the Messenger *today find their way to front lawns not from a bicycle but from the window of a venerable 1991 extended-cab Chevrolet S10 pick-up. Jon-Tyler drives. Kelly finishes rolling the rest of the papers in the cab, slipping on plastic sleeves while skillfully launching them onto lawns with one hand.*

"How do you know which front step gets the paper each day?" I asked Kelly.

"After a while, you just know."

Asked about his accuracy at tossing papers out the window, he modestly says, "I'm pretty good at it." Indeed. He has the athletic build and concentration of a star baseball player, coupled with a quiet earnestness.

Only a few papers are still delivered on foot. Kelly rolls these and inserts them into a large, white canvas bag that is stamped with "The Messenger" in black, block letters, which he carries into the local nursing home to deliver to residents.

"Why do you do this job? I asked him.

"It's in my blood," he said. "At first I did it for the money, but now I do it to help the family."

There are a lot of people counting on him. Most of his family works here; even his grandmother still keeps the books in the office. This is a business that has defined the family, as well as the community. And one that requires more dedication than ever, to keep it alive in this age of internet news and cable television.

Sports Page. Paper carrier,
Union City, Tenn.
Watercolor on paper,
29 3/4 x 22 3/4 inches, 2009

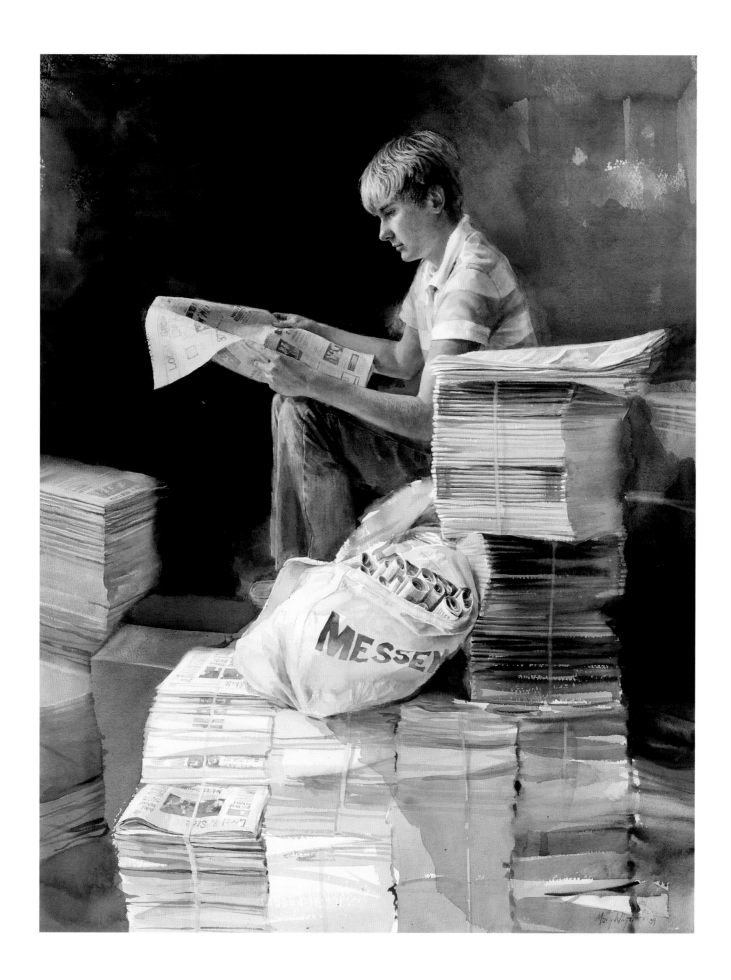

64 *Pilgrimage.* Funeral band, Miami, Fla.
Watercolor on paper, 39 x 48 inches, 2009

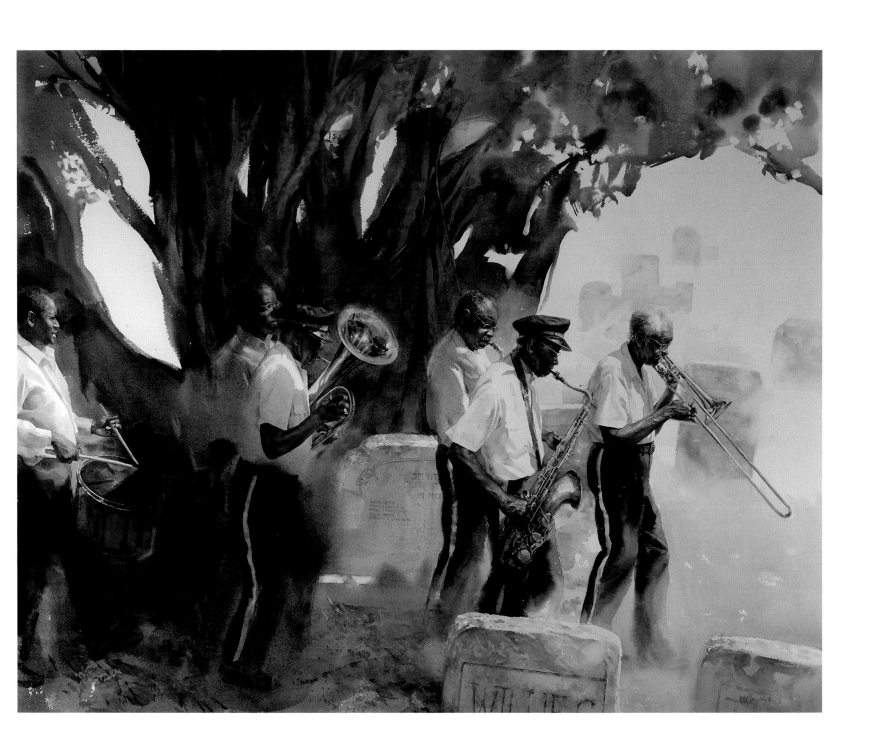

66 *Black Liquor.* Paper mill employee, Canton, N.C.
Watercolor on paper, 29 x 20 inches, 2007

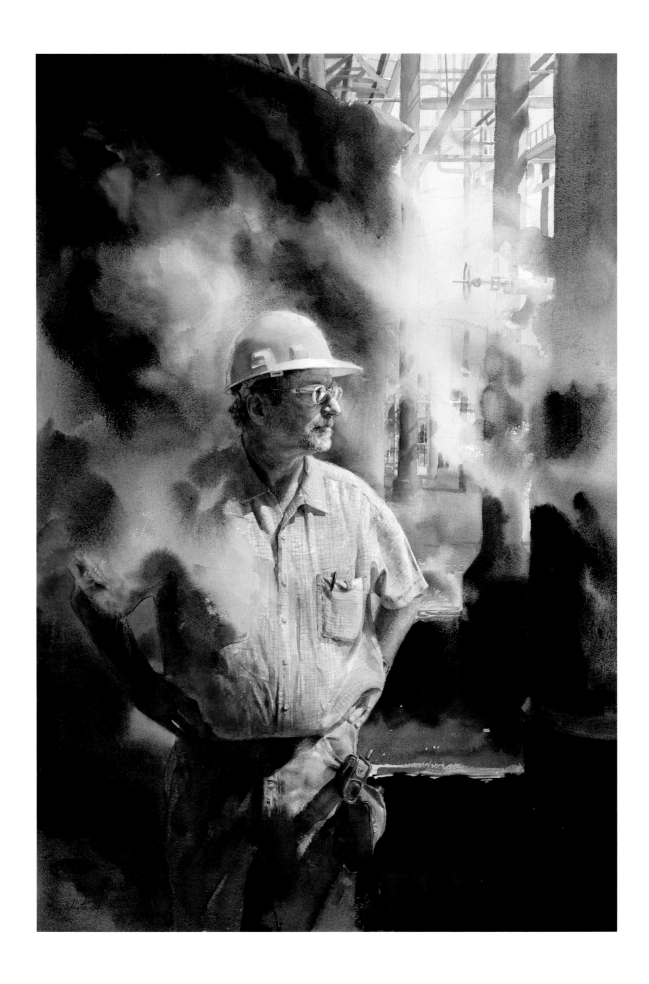

The Kentucky River moves slowly here, elbowing itself between the hills. It is the color of a moss-green agate. The mist joins and dissipates like small white ghosts as the ferry chugs across, sending up a ribbon of smoke into the pale sky. Geese paddle between swirling eddies, leaving their signature for a moment before it is erased by the ferry. The road on the other side of the river carves down a steep hillside to the landing, as three cars wind slowly to the water's edge. Just before the ferry glides to a stop on the bank, the engine cuts off, and a man jumps ashore to tie the rope.

I have been riding back and forth on the ferry all morning. Finally, I disembark and hike up to the top of a grassy hill, with a wide view up and down the river. I set up my easel. The ferry now looks like a floating toy in a bath tub, like it did when I first drove down the embankment to the small landing.

Captain Will Horn goes back and forth all day between the landings, loading three cars at a time in each direction.

"I work between twelve and sixteen hours a day," says Capt. Horn. "It's a fine way to make a living. Long as you take care during flood season when big trees can come floating downriver."

This is the same boat that helped transport Union troops between Madison, Jessamine, and Fayette counties. The ferry was established here in 1792, seven years before Kentucky became a state. Horn logs the license plate of every car he ferries, mostly commuters going to work between Valley View and Spears. He submits the report to the state transit authority, as he has been doing since he started here. He is an easy subject, captain of this old ship, no doubt the very reincarnation of the man who ferried troops in the Civil War.

A few miles up the hill I find a grocery store with a snack bar. A few plastic tables crowd in between rows of canned goods, cereal, and toilet paper. I sit down at a table and study the menu board that is behind the cook who is scraping grease off the grill. The choices are scrawled with a black marker and appear to be anything frozen that can be fried. The owner, a large middle-aged man, ambles through swinging a flyswatter on one finger—then THWHACCK! *on a tabletop. He flips the fly onto the floor.* THWAAACK! *Another thwack. Three flies meet their maker.*

"What'll you have?" the cook asks after watching me look at the menu, wiping her hands on a damp rag. She could be the owner's wife. Her round face is perspiring, white as bread dough, her eyes two large raisins. I read the menu board: "chicken parmesan."

"Can I have that grilled instead of fried?"

The cook puts down her cigarette, exhaling through barely parted lips and takes an appraising look at me, up and down. I pull my mouth into a weak smile.

"Well," she said, shaking her head, taking a long drag of her cigarette, "It'll be a first." She opens the freezer and reaches in. I hear plastic crinkle and then a searing sputter from the grill.

*The man approaches and—*THWAACK!*—nails a fly on my table.*

Crossing. Ferryboat captain, Valley View, Ky. Watercolor on paper, 15 1/2 x 30 inches, 2009

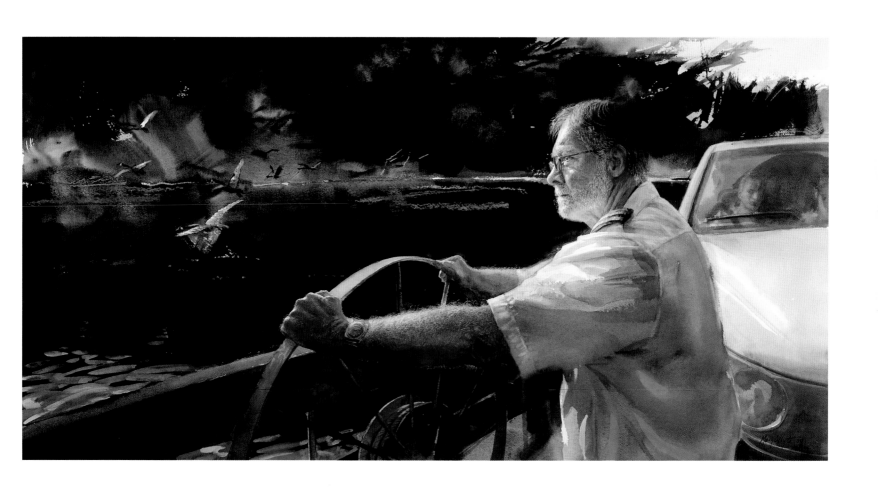

70

Beekeeper's Daughter. Beekeeper, Simpsonville, S.C.
Watercolor on paper, 28 3/4 x 21 3/4 inches, 2008

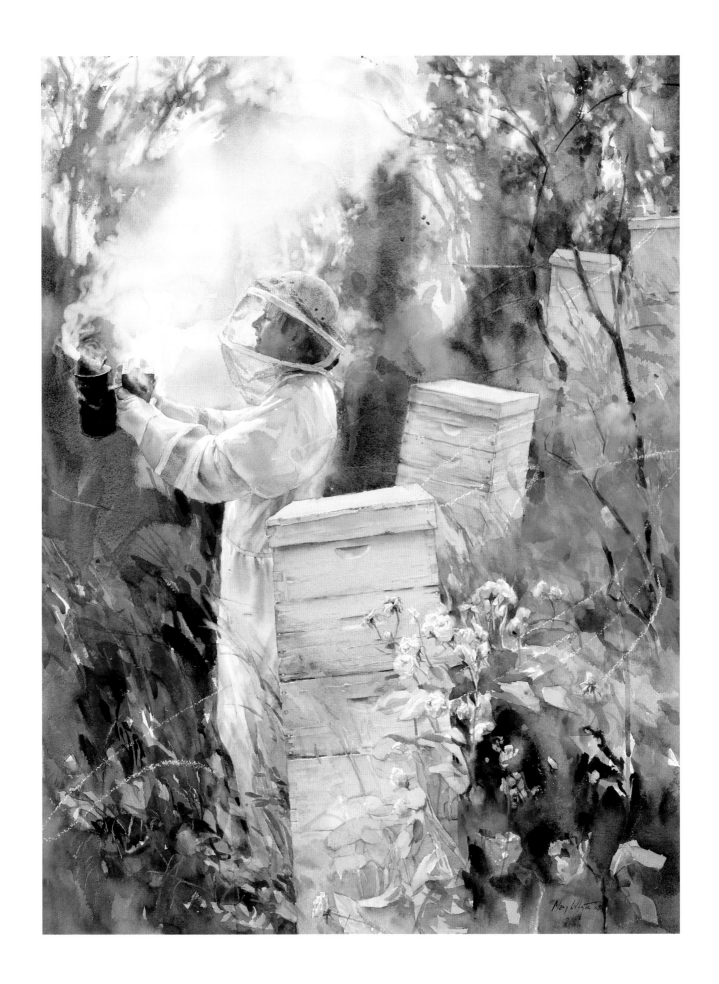

November 2
Gretna, Virginia

I am in an enormous red pickup truck, holding onto the passenger door and seat belt as another truck coming toward us moves over to the side to let us shoot past, sending gravel skittering. Next to me is Joe Fuller, whom I have now known for ten minutes. He raises one finger up off the steering wheel in acknowledgment to his neighbor. His other hand is holding a cell phone to his ear. We turn off the road and into a wide field long spent from summer, brown grass pressed flat from recent frosts. A few cows in the adjacent field look up and slowly lumber toward the fence. By now most of the tobacco has been harvested, leaving behind rows of beleaguered dark stalks, still standing in formation.

Joe drives the truck to the crest of the hill and then down the other side, along a row of tall trees. Their thick trunks wind over and through a barbed wire fence that cuts deep into their sides. Thin fingers of branches above us tentatively hold a few yellow leaves. Near the guardian trees, a gentle slope hidden from view holds rows of ruffled leaves with purple flowers that reach skyward. Joe stops the truck, and we get out.

The air smells like peat moss and earth. It is the first time I have ever seen a field of tobacco.

You can tell when a man has done one thing all his life: he owns the air. Joe strides down between the rows of tobacco, snapping off purple flowers and tossing them behind him like spent money. Along the way he tells me about how he started stripping and drying tobacco when he was seven years old.

"I bought my first tractor right out of high school," he says, smiling. "I was so proud of it, I drove it into town to the car wash. They ribbed me something bad about that one."

The field gradually dips further, and at the bottom is a small tobacco barn. It rests in the hammock of the terrain like it slid down the hill and decided to stay there. It is the barn where, as a child, Joe would climb up high onto the cross beams, stringing rows of pungent tobacco. Everything here is the color of dried tobacco, the smooth timbers of the barn, the mud packed between the smooth timbers, even Joe's skin.

We stand just outside the low doorway. The air is crisp. The building is patched in a few places with sheets of tin, reflecting the clear afternoon light.

We talk about the future of tobacco farming—if it has a future. The light makes stripes in shadow across Joe's body, and his face, as if he is eclipsed, somehow divided in half between the past and the future.

Eclipse. Tobacco farmer, Gretna, Va. Watercolor on paper, 22¼ x 30¾ inches, 2009

72

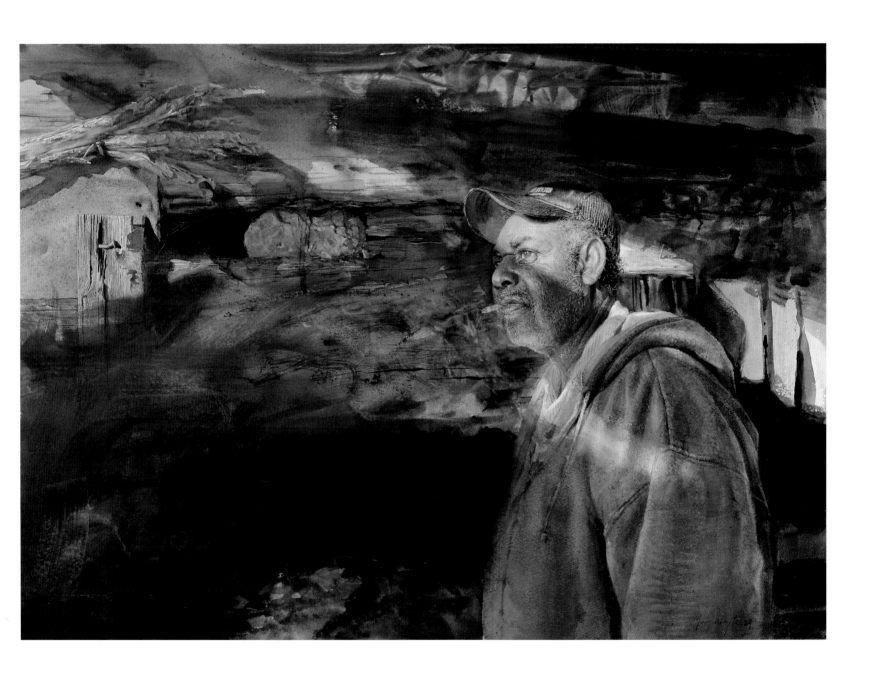

Pearl. Oyster shucker, Urbanna, Va.

74

Watercolor on paper, 22 1/2 x 30 1/4 inches, 2009

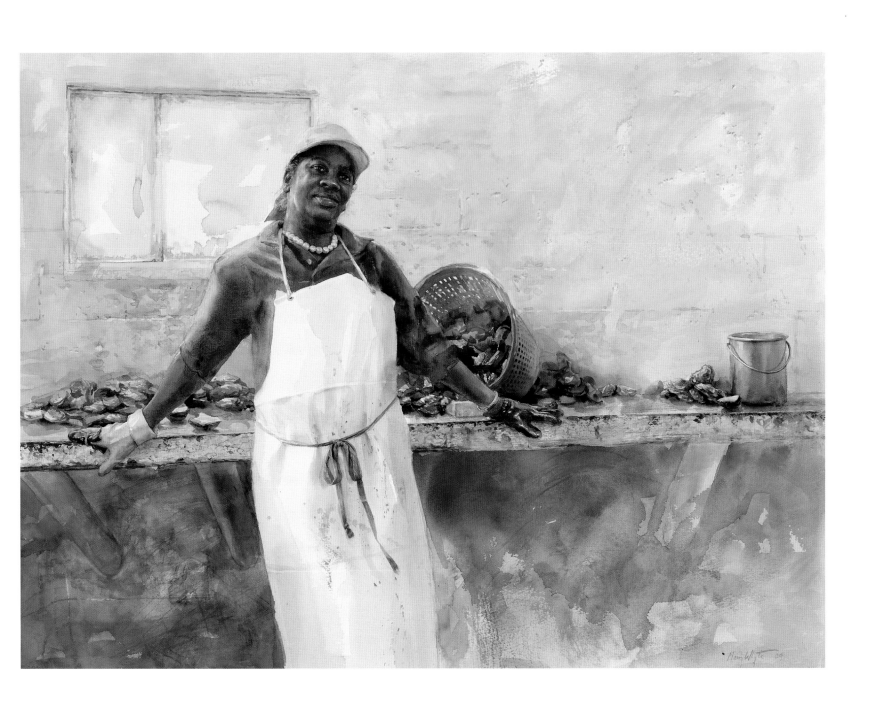

Hull. Wooden-boat builder, Bayou La Batre, Ala.
Watercolor on paper, 37 x 29 inches, 2008

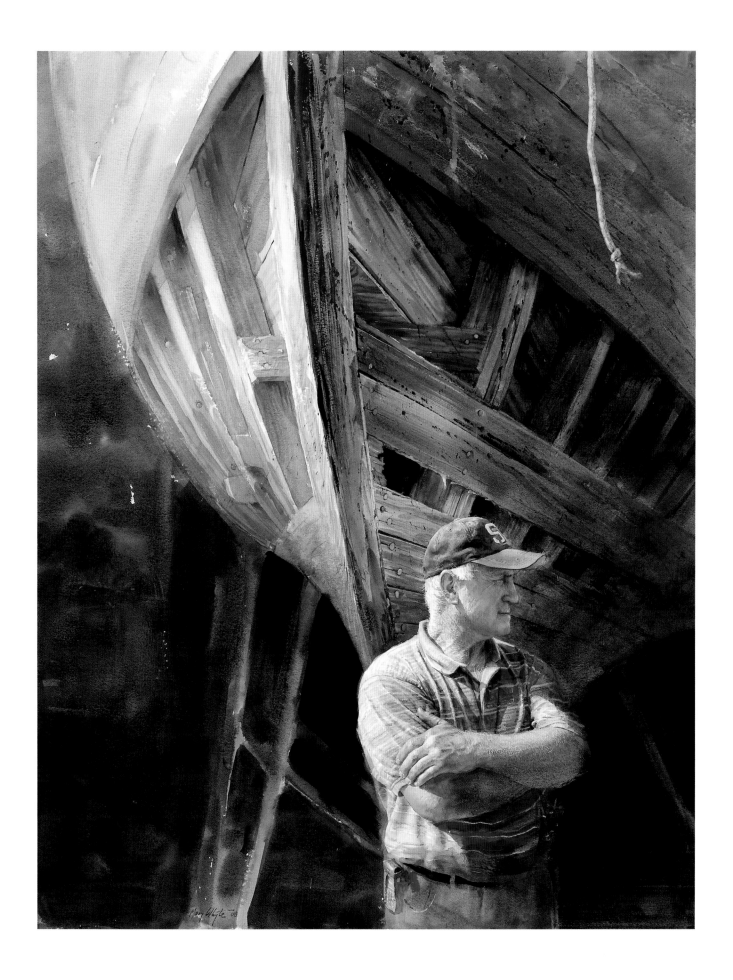

December 6
Apalachicola, Florida

The air is curdled with smoke. Papery ashes float past the men heaving burlap bags filled with oysters up onto the dock and then onto the scales. I stand upwind of the burn pile, a carpet of thick shells crunching under by feet. By now most of the oystermen are coming in from the bay, their boats chugging low and heavy in the water.

My easel is set up near the edge of the water. I have prepared the watercolor paper, and it's perched on the easel, blank, waiting. I cup my hand to shield the low sun from my eyes, looking for Wade Barber's boat. In the distance I see it, a hyphen mark with a red dot: his red knit hat.

I have already been on Wade's boat. Yesterday he agreed to take me out with him into the bay so that I could see and hear about how oystering is done. We'd puttered out into the bay in his narrow fishing boat, which is essentially a small stern cabin surrounded by gunwales. Wade sat on the cabin's tiny window ledge, leaning his head out to the side as he steered with one hand. He had politely given me his usual seat, an overturned white bucket with a carefully folded towel on top, leaving barely enough room for our feet and my gear. The small craft pushed over gentle swells, past a series of small islands, the fish houses and abandoned restaurants on shore reducing to a smudge. When there was an endless expanse of shimmering blue spread out around us, Wade shut off the engine so he could get out the long tongs that he used to rake the oysters up from the belly of the bay. Nearby a half-dozen other bobbing boats cradled shapes of bent figures. One man raised his hand in half of a wave.

I had never been on an oyster boat before. I knew nothing about how it was done, so I had come prepared with two sharpened pencils ready for pages of notes. Wade had collected oysters as a child with his father, and now, years later, he still went out most days to help support his granddaughter and her new baby. I watched as the slim man lowered the long wooden pincher rakes into the shallow water, hitching his way along the narrow exterior rim of the boat as he scissored the poles together. I could hear the muffled sound of shells clacking together beneath the gentle water.

"You rake the oysters up like this," Wade explained over his shoulder. He lifted a dozen rocky oysters out of the water in the giant tongs and dumped them onto the culling board, water running down the wooden plank in narrow rivulets. He shook the tongs once, releasing one remaining oyster that landed with a clunk.

"And then you do it OVER *and* OVER *and* OVER *again," he said, turning back to lower his tongs into the water.*

I waited, my pencil ready.

He said nothing more and continued his raking.

78

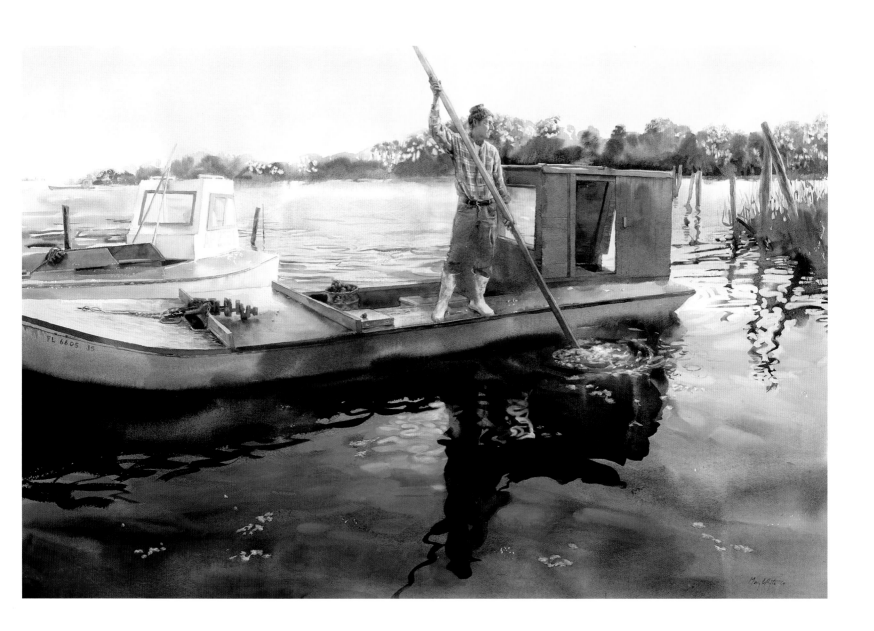

80 *Fourth Floor.* Elevator operator, Jackson, Miss.
Watercolor on paper, 32 $\frac{1}{2}$ x 22 $\frac{1}{2}$ inches, 2009

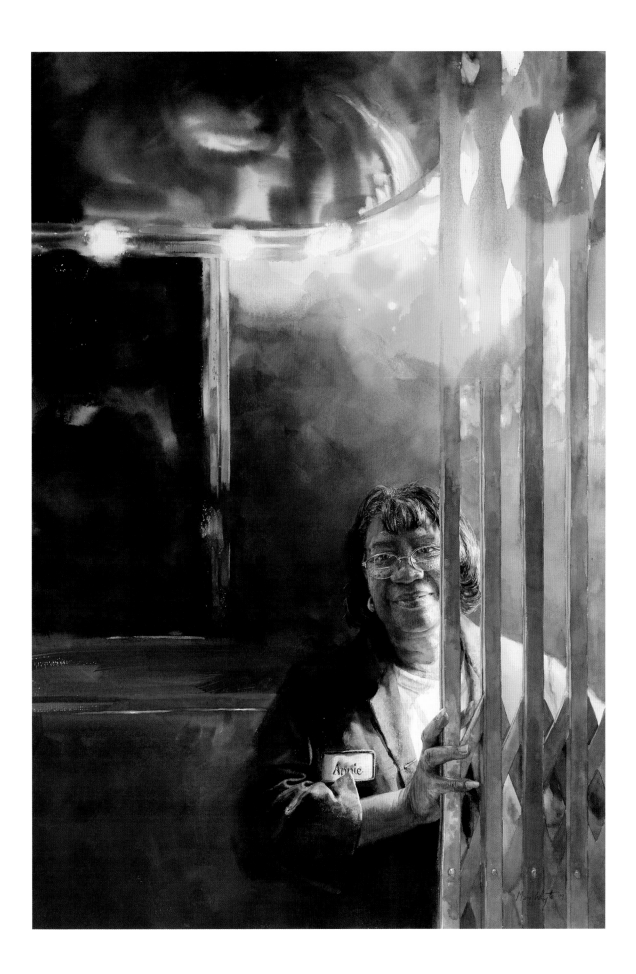

Cotton Man. Cotton picker, Bishopville, S.C.

Watercolor on paper, 40 1/2 x 27 1/2 inches, 2007

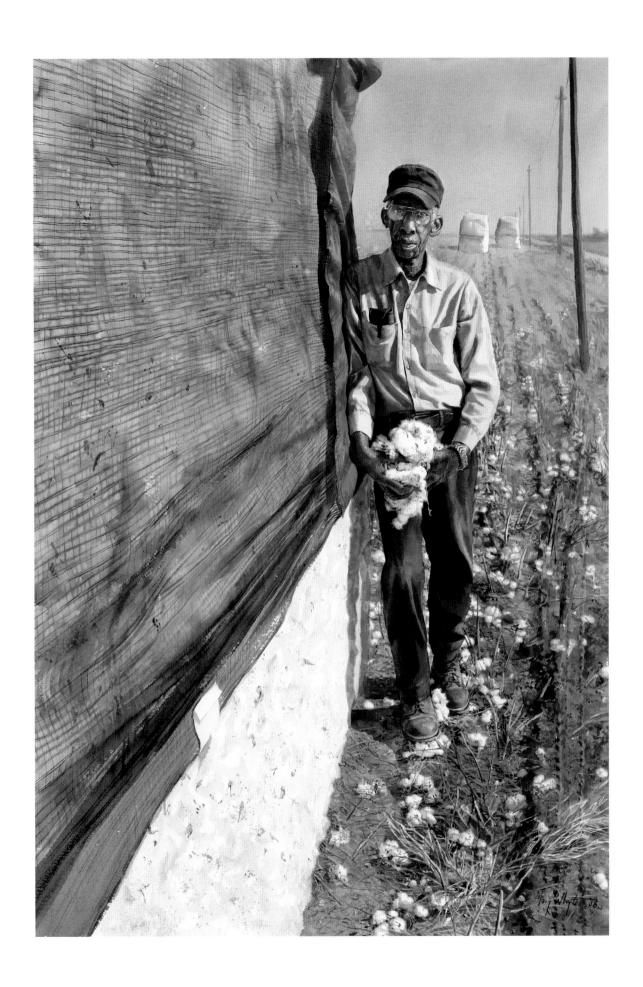

Nov. 2, 2009 Gretna, VA

Tobacco farmers are becoming scarce, as many are switching over
to organic vegetables. The auction houses, as far as I have learned, have
all disappeared. But, after many phone calls I found Joe Fuller,
born in 1954, a year before me. His father grew tobacco, and Joe
said he remembers working tobacco when he was 6 or 7, walking
His farm is an assortment of buildings vehicles and
structures. He collects trailers and he
photos for a scant help
first ti till in
 bus.
 sition—

 no luck

 you
 to work."

 he took alot of teasing
 farming, especially when he bought his
 tobacco in 1975. Proud of his new purchase he
"took it to the car wash to clean it up. Really got
ribbed about that something bad."

tobacco 1930's 10-15¢ lb. Now 1.87-2.00 lb. 4.00 organic.

Eclipse

20x 30

THE STUDIES

Mr. Noah. New Orleans, La.
Watercolor on paper, 87
10 x 8½ inches, 2008

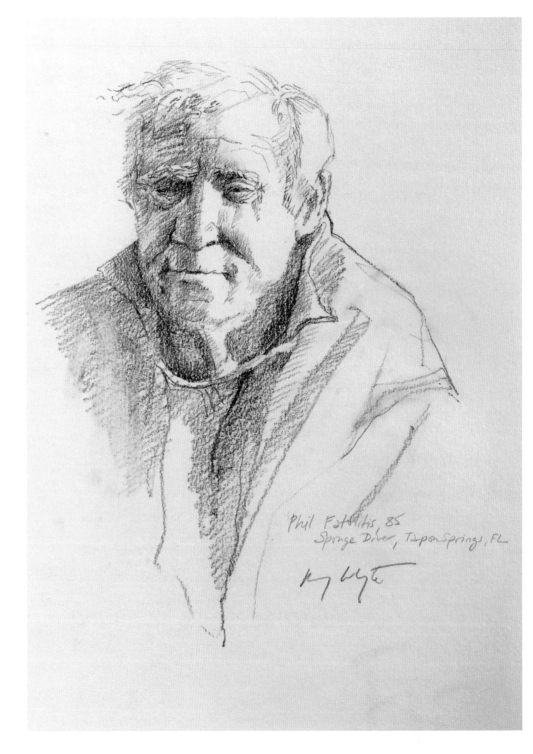

Diver. Tarpon Springs, Fla.

Graphite on paper,

10½ x 7¾ inches, 2009

Ferry. Valley View, Ky.
Watercolor on paper,
8¾ x 10 inches, 2008

89

Second Shift. Gaffney, S.C.

90 Watercolor on paper,
13 x 10$\frac{1}{2}$ inches, 2007

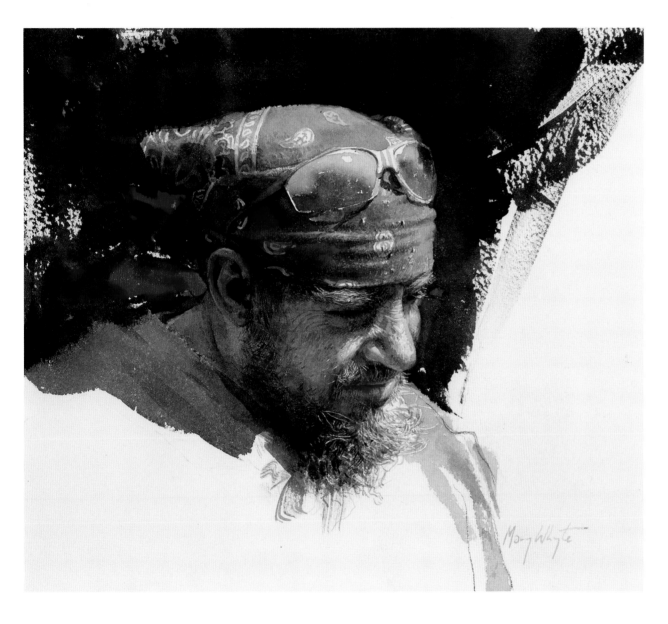

Pit Man. Bishopville, S.C.
Watercolor on paper, 91
8¼ x 9½ inches, 2008

Lumberman. Fulton, Ala.

92 Watercolor on paper,

10 x 14 inches, 2007

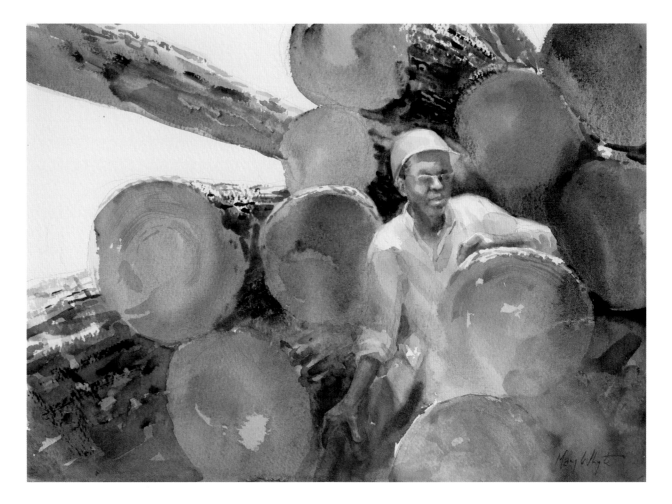

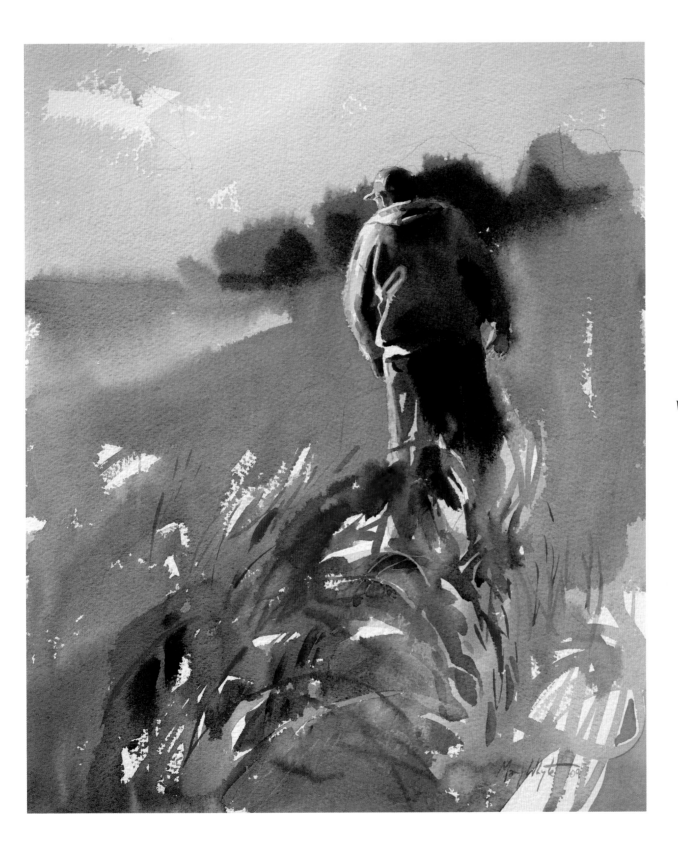

Winter Field. Gretna, Va.
Watercolor on paper, 93
14 1/8 x 11 3/4 inches, 2009

Fresh Ink. Union City, Tenn.

94 Watercolor on paper,
7 x 7¾ inches, 2009

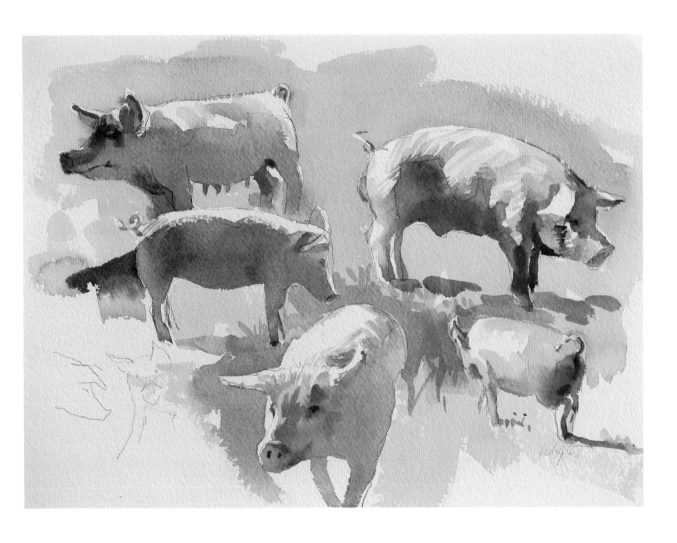

Pigs. Gray Court, S.C.
Watercolor on paper,
10¼ x 14¼ inches, 2010

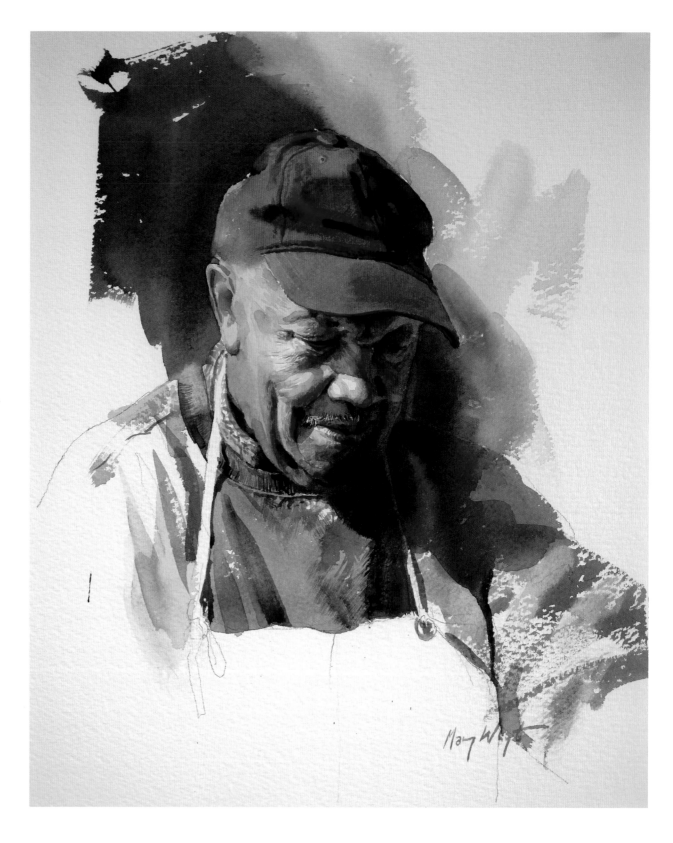

Obediah. Hacks Neck, Va.
96 Watercolor on paper,
12³⁄₄ x 10 inches, 2009

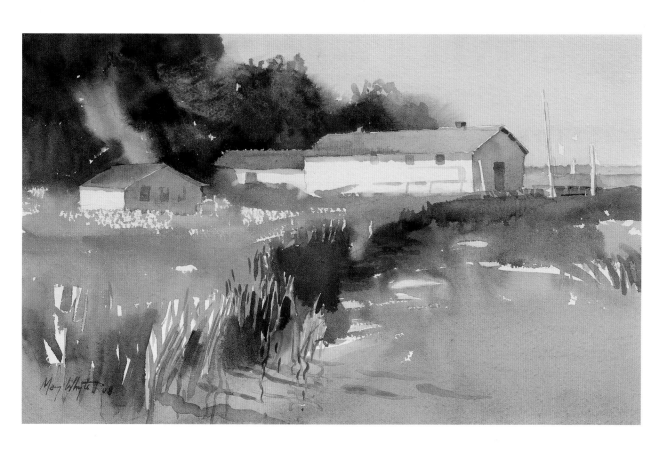

Pin Point. Pin Point, Ga.
Watercolor on paper, 97
8 x 13 inches, 2007

Watching the Chess Game.
New Orleans, La.
Watercolor on paper,
7 x 5 3/4 inches, 2008

Concession. Lewisburg, Tenn.
Graphite on paper, 99
10 1/2 x 7 3/4 inches, 2009

Drummer. Miami, Fla.
Watercolor on paper,
14 x 11 inches, 2009

100

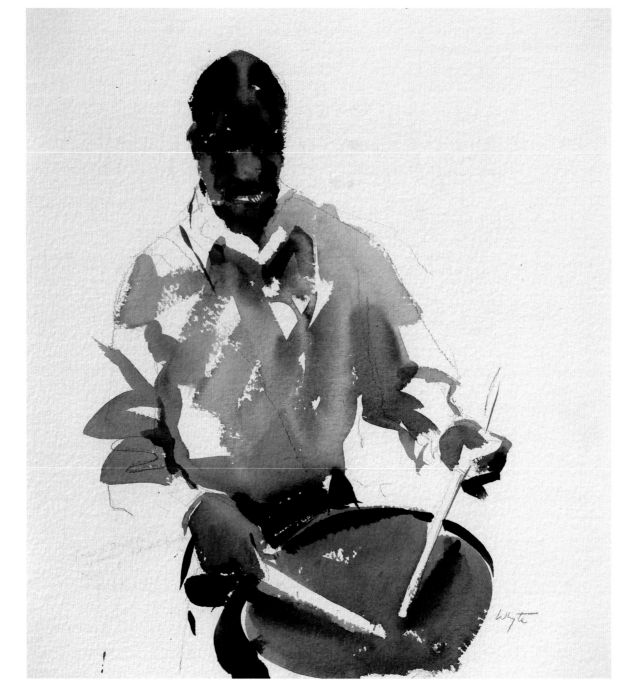

Music Men.
Pumpkintown, S.C.
Graphite on paper,
$10\frac{1}{2}$ x $7\frac{3}{4}$ inches, 2007

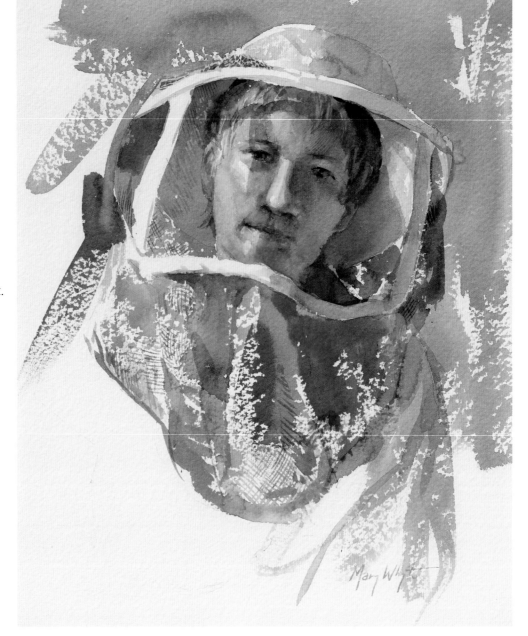

Beekeeper. Simpsonville, S.C.

102 Watercolor on paper,

12 1/4 x 9 3/4 inches, 2008

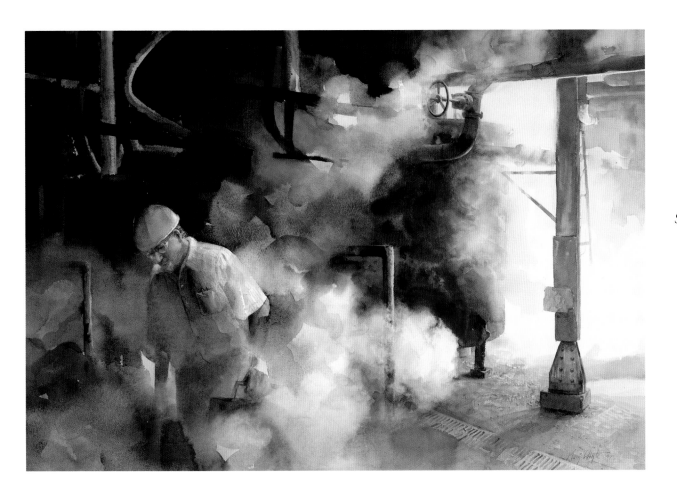

Study for Black Liquor.
Canton, N.C.
Watercolor on paper,
19¾ x 28¾ inches, 2007

103

Red Cap. Apalachicola, Fla.
Watercolor on paper,
9 1/4 x 7 1/2 inches, 2009

104

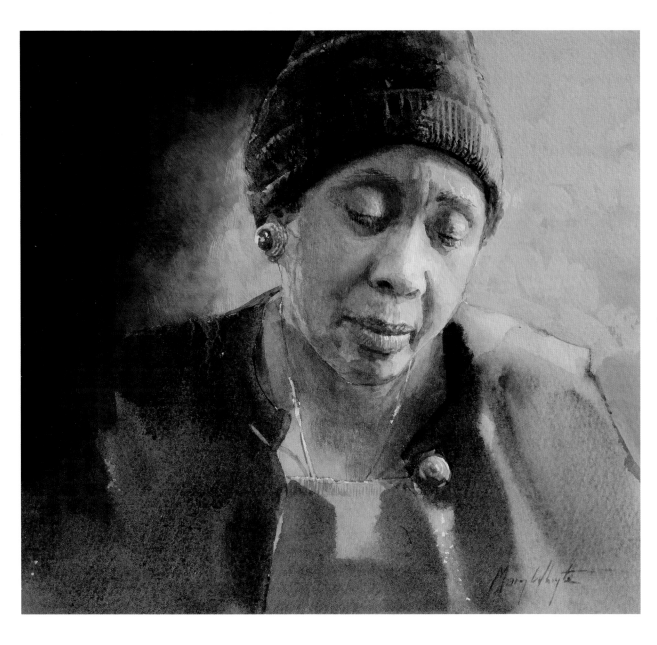

Milliner. Atlanta, Ga.
Watercolor, $8\frac{3}{8}$ x $9\frac{1}{8}$ inches, 105
2009

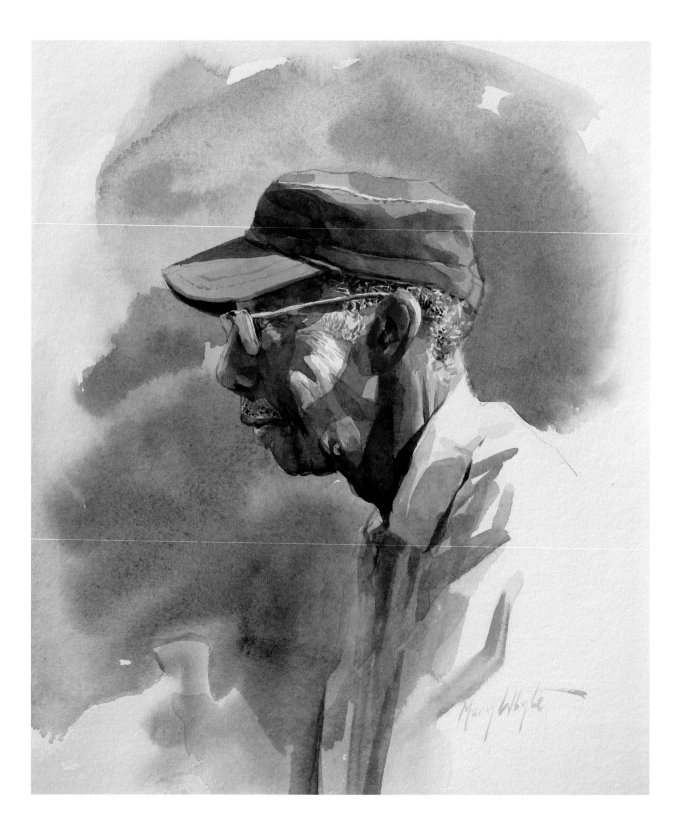

Blue. Bishopville, S.C.

106 Watercolor on paper,
 9 x 7½ inches, 2007

May 12
Fort Valley, Georgia

At night Georgia state highway 96 is blacker than the inside of a boot. Along its many miles there are a few sporadic street lights, and, on the left and right, there is nary the tiniest yellow dot of a house window. I am heading home, with my leather bag next to me on the front seat, containing my paints, camera, and sketchbook.

I had gotten off schedule, driving around rural Georgia. But how could I not? With places on the map called Montezuma, Hopeful, Snapfinger and Experiment, one simply must drive over and have a look. It is now nearly eleven o'clock on that black highway. Finally I spot the lights of a brand-new boxy motel on the side of the road, lit up like a pinball machine on a little carpet. A year before, this spot probably held cows out to pasture.

The front deskman greets me, sort of, with a stifled yawn and a rehearsed litany of the amenities: pool, exercise room, coffee, breakfast starting at 6 A.M. A bowl of bruised apples lies sleepily on the reception desk. I am handed my card key and tote my two bags to the elevator. No elevator operator here, just a panel of lighted floor numbers 1–5 and an ad on the wall for a chain pizza delivery.

The room smells like strawberries and Mr. Clean, but I sleep like the dead. In the morning I shower and dry off with a scratchy towel. I repack my bags and head to the breakfast room.

I peruse the buffet line-up. Boxes of dry cereal, muffins in plastic wrap, a few greenish-white bananas, coffee, and juice. On the front of the steel juice machine is a cartoon drawing of a dancing sun wearing sunglasses. I push the button and out flows a trickle of orange juice. I pick up a plastic plate and a plastic fork the size of my thumb. It bends. How can anyone actually eat with these things? I flop a spongy, coaster-shaped scrambled egg on the middle of my white plate.

There are a few other people in the cafe area. Two men and a woman are wearing baseball caps, jeans, sweatshirts, and sneakers. I wager to myself that none of their clothing was made in the United States. I recall the milliner and the shoe shine man, as well as the many textile mill workers I had met in the course of three years traveling southern highways. The large flat screen mounted over the coffee station is showing the news. I don't see any newspapers.

I sit at a faux wood table, on a chair upholstered with polyester. The factory country curtains have a homey print, imitating a hand-stitched quilt. I push the egg around on the plate with my fork.

I see the head and gray hair of the woman from the front desk, sitting at a table with a large cardboard box in front of her. She is craning her neck, peering into the box, pulling out handfuls of white forks and knives that are wrapped in crinkly plastic. She looks like a small owl, poking up the glasses on her nose, chirping "Good morning!" to the guests as they shuffle in. Her head swivels on her thin neck as she scans the buffet and tables to see if anything needs attention.

The weather comes on the TV news.

"Whoo-wee, it's cold for May," says the woman with the "cutlery." "We ain't had a spring this cold for a long time. Me, I'll take the hot weather any time. I like the HOT." No one answers. She pauses. She glances at the others, then at me.

"You from around here?"

I tell her I am heading toward Charleston. She tells me she has relatives in Ladson, just north of the city—two cousins, brothers who sell used auto parts.

"Charleston is a really pretty place, with all those old-timey carriages and big houses. The aquarium is nice, but who would want to watch sharks? Me, I can't swim. We ate once at that fish place, you know, the one everybody goes to?" She chatters on, wrappers rustling in her hands. I finish my cup of tea and get up to toss my trash into the receptacle. Setting my bag on the table, I reach into my purse.

"Thank you," I say, setting a couple of crumpled bills on her table next to the growing mound of plastic.

"You have a good day," she says. "Oh," she says, peering over the box and reaching to pick up the money.

I grab my overnight bag in one hand and sling the camera bag over my shoulder and turn toward the exit. As I push open the glass door to the parking lot, I hear the woman exclaiming behind me:

"Well, my, oh my! It just goes to show you! You just never know what God has in store for you every day."

Outside I can smell the blooms of spring as the sun bursts its way through the crisp morning. The light feels good on my face as I walk to the car, unlock the door, and toss my bags on the front seat. I start the car and roll down the windows, and head for Seabrook Island.

INDEX